W9-BLJ-846

Start with a Digital Camera
Second Edition

Start with a Digital Camera

SECOND EDITION

The Indispensable Guide to Getting the Most Out of Your Digital Camera

by John Odam

Special Contributor
Tim Odam

Start with a Digital Camera, Second Edition:
The Indispensable Guide to Getting the Most
Out of Your Digital Camera

John Odam

Peachpit Press
1249 Eighth Street
Berkeley, CA 94710
(800) 283-9444, (510) 524-2178
(510) 524-2221 (fax)

Find us on the World Wide Web at:
http://www.peachpit.com

Peachpit Press is a division of Pearson Education.

Copyright © 2003 by John Odam

All rights reserved. No part of this book may be repro-
duced or transmitted in any form or by any means, elec-
tronic, mechanical, photocopying, recording, or otherwise,
without the prior written permission of the publisher. For
information, contact Peachpit Press.

Notice of Liability:
The information in this book is distributed on an "as is"
basis, without warranty. While every precaution has been
taken in the preparation of this book, neither the authors
nor Peachpit Press shall have any liability to any person or
entity with respect to any liability, loss, or damage caused
or alleged to be caused directly or indirectly by the instruc-
tions contained in this book or by the computer software
and hardware products described herein.

ISBN 0-321-21900-7

0 9 8 7 6 5 4 3 2

Printed and bound in the United States of America

To Panny and Wowo for all their help and support.

ACKNOWLEDGMENTS

This edition would have been impossible without the indispensable contributions of Tim Odam, who not only has provided much valuable research but also most of the new photographic material.

I have also relied heavily on Michael Price for his expert and timely advice on matters of professional photography.

Thanks to the following people who served as photographic models: Kevin and Annie Allshouse, Janet Ashford, Erik Blegvad, Romilly Browne, Mary Brown, Alison Calloway Jones, Jacob Chemnik, Ed Cormier Senior and Junior, Luisa, Lilliana and Jennifer Corredor, Peter Damashek, Garrick and Zacharay Davis, Peter DuBois, Drew Gallahar, Vykki Mende Gray, Vinny Ha, Patti Jelley, Tess Kolstad, Janet Martini, Alastair Norman McCloud, Alex and Luke Odam, Abby and Caleb Odam, Patric Petrie, Eddy and Harry Reeseman, Jerry Schreiber, Yan Simone, and David Swarens. And thanks, too, to the British contingent—Seth, Zak and Jemmimah, Lucy and Sunny, Erica and Harvey, Jo and Debbie—who also modeled for the book.

Thanks also to the following people and organizations for their help in providing environments and props: Doris Bittar, Clone Duplication, Vykki Mende Gray, Metropolitan Biosolids Center, Caleb, George and Seth Odam, Jonathan Parker, San Diego Cycling Club, and Holly Witchey.

Mike Sawyer at Interface Ltd. deserves special thanks for providing a demonstration of large format inkjet printing.

Finally, I am grateful for the expert technical advice of Jack Davis, Jan Deligans, Bill Hochman, and Cher Pendarvis. A very special thanks is due to Nancy Davis and Suki Gear for their sagacious and intrepid editing, to Lisa Brazieal for production assistance, to Karin Arrigoni for her indexing, and to Nancy Ruenzel and Victor Gavenda of Peachpit Press for their enduring support of this project.

Contents

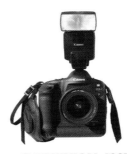

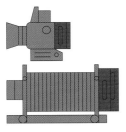
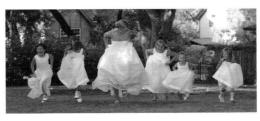

1 Getting Started

Introduction

HOW THIS BOOK CAME TO BE WRITTEN

When the first edition of *Start with a Digital Camera* was published in 1997, the digital camera was still somewhat of a novelty, and greeted with skepticism by established photographers and graphic artists. Since then the digital camera has gained wide acceptance in all fields of photography, including the ever-increasing online media. With these new developments, the time was right to create a new edition of one of the first four-color books to be published on the subject.

Start with a Digital Camera, together with *Start with a Scan,* and *Getting Started with 3D,* which I co-authored with Janet Ashford, are based on a creative approach to a technical subject, providing just enough how-to information to empower the reader to master a new technology. Lots of examples suggest ways in which this technology can be useful both in business and for pleasure, sharing the results of experiments in developing the design possibilities of digital images.

THE DEVELOPMENT OF DIGITAL PHOTOGRAPHY

Digital photography—of sorts—was in use long before we had scanners. In 1985 I set up what was then known as a "desktop publishing" system, which was regarded with some suspicion by printers and typesetters. A couple of years later I connected a black-and-white video camera to the computer via an analog/digital converter box. These early pictures were low-resolution and limited to black and white dots. A year or so later, advances in software made it possible to record images in 16 shades of gray. Crude though it was, I found the system useful to make templates from artwork, which I could then trace in a drawing program, and to make placeholder images from photographs that would ultimately be reproduced by conventional printing. But by the end of the decade, scanners—first grayscale, then color—became the tool of choice, and the video system and its tangle of cables was put away and forgotten in the bottom drawer.

Around 1995, I noticed a digital camera advertised in a computer catalog. Remembering the fun I had with the old video system, I decided to order one and try it out. I was not impressed. Yes, there was color now, and the camera was portable, but the images were blurry and low-resolution—no better than a video "frame grab." Frustrated, I gave the camera away and went back to scanning photos.

But during the last years of the 1990s the graphic design grapevine began to signal that the digital camera had advanced rapidly. Trusting that this volatile technology was worth reconsidering, I invested in a mid-priced model. I was just as impressed with my second digital camera as I had been disappointed in my first one just a few years before. It inspired me to write this book.

Today there are hundreds of models of digital cameras available, ranging from tiny devices that fit in the palm of your hand to full-blown professional single-lens reflex models.

Early digital photography
Digital camera images circa 1987, taken with a video camera and an analog/digital converter.

WHAT THIS BOOK IS ABOUT

Start with a Digital Camera presents a multitude of creative ways to use your digital image. Whether you are about to purchase a digital camera—or already have one and are not quite sure what to do with it—this book gives you both the knowledge and the inspiration to generate excellent digital photographs and incorporate them in graphic design.

You'll find out what kind of camera is best for you, how to manage memory and storage, how to set up your studio, and how to work with models and props. You'll also get a sense of the power of the digital camera as a creative tool, with lots of graphic design case studies. Artists, designers, photographers, and desktop publishers will get valuable tips on using digital photos in publications, on the Internet, and in limited-edition prints.

Start with a Digital Camera will show you how to overcome the limitations of digital photography, and how to maximize its unique advantages. With hundreds of clear step-by-step examples, this book will take you through the process of creating graphic design with digital photography: first, seeing what's there, recognizing form, tone and color; then editing the digital image to bring it a step further to its end use in print or on screen; finally, integrating the photograph into powerful pieces of visual communication.

IS THIS BOOK FOR YOU?

This book is written for those who are interested in both photography and design. You might be a professional photographer and an amateur designer, or, like the author, a professional designer and an amateur photographer.

Specifically, there are four kinds of reader whom this book addresses:

• experienced photographers and designers who are looking for ways to develop their skills and extend the range of their craft into new media

• members of the business, professional, and educational communities whose duties include communicating visual information

• students and people new to computer and

State of the art
Crisp, high-resolution images are possible even with modestly priced digital cameras. *Photo by Tim Odam.*

digital camera technology who are curious about what can be done with this medium

• amateur photographers who are venturing into a new technology and just want to have fun with it

EQUIPMENT AND KNOWLEDGE YOU WILL NEED

This book is not intended to be a substitute for a software manual. It presents a broad overview of what is possible with a variety of programs, and here and there I'll demonstrate a specific procedure. Remember there are many different ways of accomplishing the same goal—especially in programs as deep and complex as Adobe Photoshop. You will, of course, need some kind of digital camera and will need to know how to operate it. (Yes, you must read that leaflet with the dire warnings about electric shocks.) You'll need a basic familiarity with a personal computer system—Windows or Macintosh—an image-editing program such as Adobe Photoshop or Photoshop Elements, and page-layout program such as Adobe PageMaker or InDesign. It also helps to have an inkjet printer. Although the examples of software interfaces in this book are from a Macintosh running OS X, the same effects can be just as easily achieved with Windows or any other current operating system.

Digital photography is a new territory, and you are the explorer. An open mind and limitless patience are worth far more than years of experience.

How to Use This Book

LEARNING BY LOOKING

Start with a Digital Camera is a visual book about a visual subject. Although I have tried to provide concise and informative text, it should still be possible to get a lot of information from this book simply by looking at the images and captions.

The book is packed with images that are designed to keep the pages turning, stimulating your interest in all the things that can be done with a digital camera, and encouraging you to try out some of the techniques on your own computer. The book is meant to stimulate thinking about photography and design, and about how your digital camera and computer can work together as creative tools. When you see something you might want to try, just read the caption next to the image. It will give an overview of the technique to get you started. Further details and background on the images and techniques are in the running text.

HOW THIS BOOK IS ORGANIZED

Start with a Digital Camera is divided into sections organized around originating digital photographs, manipulating them in various ways, then applying them in different types of media. If you are new to digital photography you might begin with Chapters 2 and 3, which deal with the general operation of the camera and how it works with computer systems. Bear in mind that *Start with a Digital Camera* is not primarily a *technical* book on digital photography.

Although the chapters are arranged in a linear sequence, I invite you to dive in at any point. For the most part, each page or spread is a self-contained discussion of a particular idea or approach.

The topic of each chapter is subdivided into different sections. Under each section, examples of digital photos are accompanied by captions and explanatory diagrams. Examples of how digital photography can be incorporated in graphic design are set off with a soft shadow. Sidebars on beige backgrounds or within boxes are self-contained discussions on special topics.

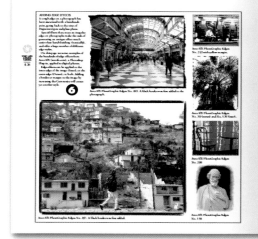
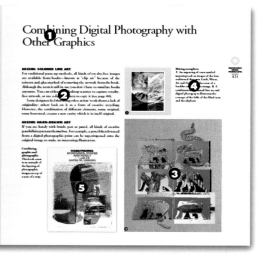

1 Section title

2 Explanatory text

3 Digital photography examples that demonstrate concepts

4 Captions describing methods

5 Examples of digital photography applied in design

6 Sidebar on a related topic

2 Getting to Know Your Camera

Digital Cameras and Their Components
Digital Camera Types
New Advances

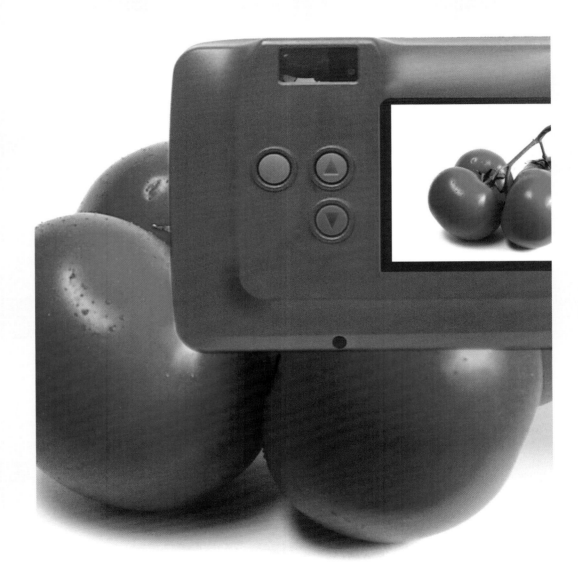

Digital Cameras and Their Components

DIGITAL CAMERA TYPES

Digital cameras fall into two broad categories: portable, general-purpose cameras and special-purpose cameras and components that require linkages with computer systems. At the heart of a digital camera system is the CCD or charge-coupled device which converts light into digital information (see the sidebar on the facing page). A similar mechanism, the CMOS, or complementary metal oxide semiconductor, is used in less expensive camera models.

SELF-CONTAINED CAMERAS

Self-contained digital cameras are portable, general-purpose cameras that do not need to be connected to an external power source or computer monitor to preview the image. Although they record pictures onto a digital medium rather than film, they function in much the same way as conventional cameras.

Digital cameras come in many different resolution formats (see pages 14–15). Resolution is the number of pixels that a camera can record at one time.

BASIC "POINT AND SHOOT" MODELS

Basic digital cameras take pictures that are low- to medium resolution (about 250,000 pixels), adequate for on-screen display. These compact and affordable cameras typically have a fixed-focal-length lens and a viewfinder. Some have close-up capability. Many also have an LCD (liquid crystal diode) display on the back to preview the image. Typically, cameras at the low or "fun" end of the market use the inexpensive CMOS sensors.

INTERMEDIATE "MULTIMEDIA" MODELS

Intermediate digital cameras have resolutions of

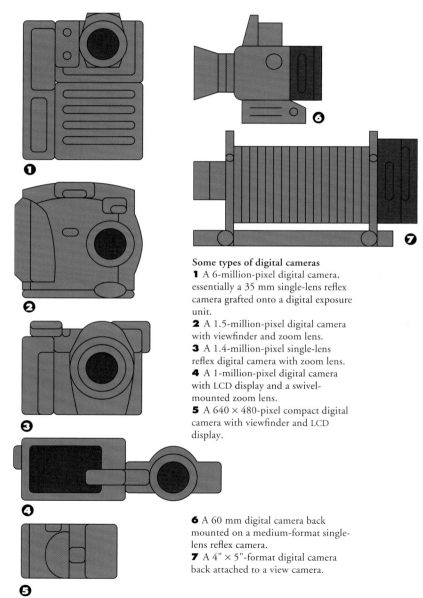

Some types of digital cameras
1 A 6-million-pixel digital camera, essentially a 35 mm single-lens reflex camera grafted onto a digital exposure unit.
2 A 1.5-million-pixel digital camera with viewfinder and zoom lens.
3 A 1.4-million-pixel single-lens reflex digital camera with zoom lens.
4 A 1-million-pixel digital camera with LCD display and a swivel-mounted zoom lens.
5 A 640 × 480-pixel compact digital camera with viewfinder and LCD display.

6 A 60 mm digital camera back mounted on a medium-format single-lens reflex camera.
7 A 4" × 5"-format digital camera back attached to a view camera.

HOW A CCD MATRIX WORKS

In a digital camera the charge-coupled devices (CCDs) are normally arranged in a rectangular matrix. Each CCD is an array of microscopic elements, each one corresponding to a pixel in the final image. Light first passes through an infrared filter layer that prevents exaggerated red values. The next filter layer consists of a mosaic of red, green and blue that breaks down the color information into three channels. In the geometry of the CCD, green filters occur twice as frequently as red or blue. The camera uses more data from green-filtered sensors because green light is better at resolving fine details in the image.

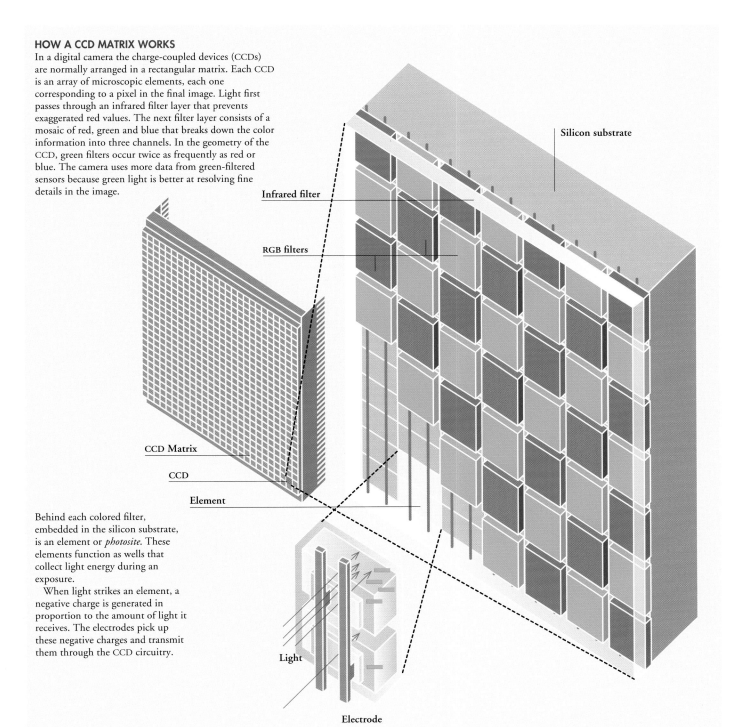

Silicon substrate

Infrared filter

RGB filters

CCD Matrix

CCD

Element

Light

Electrode

Behind each colored filter, embedded in the silicon substrate, is an element or *photosite*. These elements function as wells that collect light energy during an exposure.

When light strikes an element, a negative charge is generated in proportion to the amount of light it receives. The electrodes pick up these negative charges and transmit them through the CCD circuitry.

ANATOMY OF A DIGITAL CAMERA

Digital cameras vary in configuration, but their basic operation is similar. This diagram shows a typical camera in generalized layout.

Pressing down partially on the shutter button triggers the automatic focus and exposure mechanisms, adjusting the lenses **1** and the iris aperture **2**. In a reflex camera, as shown here, light entering the lens is deflected by a mirror **3**, through a prism **4**, to a small viewing screen attached to an eyepiece **5**.

When the shutter button is depressed completely the mirror flips out of the light path, and the CCD matrix is activated **6**. (Because the CCD is electronically controlled, there is no need for a mechanical shutter.)

The readout from the CCD matrix is processed by the logic board **7**, where it is compressed. The processed image is sent to the memory card **8** for storage, and to the LCD image display **9**. After a few seconds, the camera is ready for the next picture.

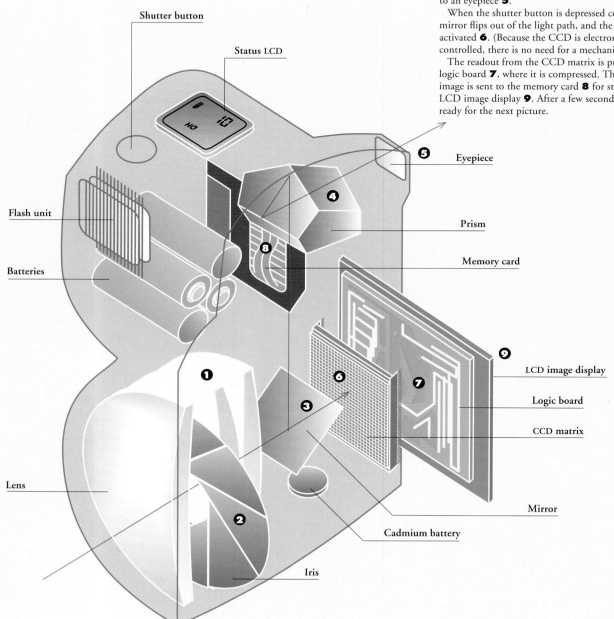

Shutter button

Status LCD

HQ

5 Eyepiece

4

Flash unit

Prism

8

Batteries

Memory card

1

9

6 LCD image display

3 Logic board

7 CCD matrix

Lens

Mirror

2

Cadmium battery

Iris

1 to 3 million pixels. This level of resolution supports ink-jet prints up to 8" × 10" and is suitable for partial-page graphic arts printing. These cameras generally have automatic focus and zoom lenses with close-up settings. Some are single-lens reflex cameras, which display the image in the viewfinder exactly as it will record. Other types of intermediate self-contained digital cameras include pivoting lens mountings that enable the LCD display to be used as a viewfinder. At the top end of this section of the market some cameras can also record brief video sequences in small-sized QuickTime or MPEG formats and be used to play MP3 formatted music files.

ADVANCED "PROSUMER" MODELS

Straddling the amateur and professional market, advanced model digital cameras may have a resolution of 6 million pixels or more. These cameras integrate a high-quality single-lens reflex camera body with a digital recording unit. Most come equipped with powerful 3-6x optical zoom lenses, and may accommodate interchangeable close-up, telephoto and wide angle lenses. In some cases pixel interpolation (a software routine to produce more pixel information) is employed, allowing, for instance, a 3.3 megapixel camera to produce 4.8 megapixel output.

EXPENSIVE "PRO" MODELS

For those who make their living at photography there is now a good selection of sturdily built professional-quality digital cameras. These cameras incorporate all the features of the "prosumer" model, but adapt to be able to use a range of lenses, filters, flash guns and fittings that may have been used with the professional's previous film camera. These models usually incorporate larger memory capacity—Microdrive and CompactFlash—allowing hundreds of exposures without having to stop to download until the action has finished.

Pro models mimic the workings of a quality 35 mm SLR, making the professional feel comfortable and in control. The ability to shoot many high-resolution shots in quick succession (burst mode) is essential for the professional photographer. However, current limitations of technology may require a tradeoff between ultra high resolu-

tion and lag-time between shots. For example, a digital photographer interested mainly in taking photos of sports and action would require a camera with lower resolution and faster response than a studio portraiture enthusiast.

DIGITAL STUDIO CAMERAS

Special-purpose digital studio cameras range from 2 to 11 million pixels in resolution. Some of these cameras have interchangeable lenses. Lacking a viewfinder or removable memory media, they must be connected to a computer to be operated.

Using a linear array of CCDs like those of a flatbed scanner, these cameras require long exposure times, and thus are best suited for still-life and product photography. Obtaining a color image may require three exposures through red, green and blue filters. Some digital studio cameras double as slide scanners and copy cameras.

PROFESSIONAL CAMERA BACKS

If you already own a professional camera with a detachable film holder, digital camera backs are available to provide a hybrid system that can shoot conventional film and record digital images. Digital camera backs are made to fit 60 mm medium-format cameras and also are available for 4" × 5" view cameras. At the time of writing, the exacting manufacturing requirements and the limited market size for professional high-resolution digital photography equipment has kept its cost relatively high. The bulky power supply units of these hybrid systems are unwieldy in most outdoor locations, although experimental high-resolution digital landscape photography has yielded stunning results.

DIGITAL CAMERA QUIRKS

Processing data
Most digital cameras use various forms of interpolation and digital manipulation to process the raw data from their photosites into a form that can be written to a memory storage medium. Interpolation means that the camera is using mathematical assumptions to fill in information that is missing. This is necessary because the photosites on the CCD are not adjacent but dispersed over the sensor area, often covering only half of the actual surface area of the CCD. Closely spaced photosites can interfere with each other's electrical signals causing *spillover* (see below).

Background noise
If you were to take a picture with the lens cap on (difficult to do) the result would be not a perfect black background but a dark texture of randomly colored pixels, or *noise*. In their resting state, photosites emit a low-level charge, causing random noise. The amount of noise is influenced by the length of the exposure and the ambient temperature, with higher temperatures and longer exposures generating more noise. Many cameras mask out a number of photosites to measure the background noise, measure the average noise level, and subtract it from the image before writing it to memory.

Spillover effect
Fringing around high-contrast details, such as the edge of a building against a bright sky, is caused by electronic spillover from a charged photosite to its uncharged neighbor (see page 82).

Emerging technology
A hexagonal array of
photosites is designed to
improve CCD resolution.

60 MM FORMAT

Digital backs for medium-format cameras, such as the Hasselblad, can record over 16 million pixels—enough resolution for an 11"×17" poster printed on a commercial press.

4 X 5 FORMAT

Designed for a studio view camera with its independently swivelling lens and camera back, connected with bellows, a 4" × 5" format digital camera back can capture up to 85 million pixels. At this level of resolution the perceptible difference between film grain and pixels disappears.

DIGITAL VIDEO AND DESKTOP VIDEO CAMERAS

Portable, self-contained digital video cameras offer a more advanced alternative to analog video. Digital movie camera technology has allowed a new wave of affordable high-quality digital video cameras which link to a computer with an IEEE connection for immediate video editing.

Digital video sequences are directly compatible with computer-based video editing. Some digital video cameras can record single frames at a higher resolution than sequential video frames. These images are comparable in quality with those from compact basic model digital cameras.

DESKTOP VIDEO CAMERAS

Desktop video cameras are inexpensive devices that are designed to feed low-resolution images directly to a computer. These cameras are best suited to online imaging and video-conferencing.

NEW ADVANCES

Advances in CCD technology have allowed new methods of gaining more pixel information. Some of the more promising developments include Intelligent Extrapolation, Pixel Shifting, Photosite Splitting, and Hexagonal Photosites. It remains to be seen which will prove the more practical.

INTELLIGENT EXTRAPOLATION

The resolution of a digital photo can be enhanced when a camera uses an *anti-aliasing* algorithm to smooth out jagged edges by filling in the missing "stair steps." In an adaptation of JPEG compression, the file size of the image is increased before being written to avoid the introduction of extra noise into the image. The drawback is that any technology that manipulates the information that the camera records, however intelligently, can compromise the accuracy of the image.

PIXEL SHIFTING

This method involves capturing one image, and then, milliseconds later, another, with the second image shifted one pixel away from the first. The images are then mixed together (or interpolated) to double the resolution of the shot—clever, unless the subject is moving.

MODIFIED PHOTOSITES

Some companies have found ways to increase resolution by changing the way the CCD is designed.

One technology splits each square photosite into two rectangular ones effectively doubling the horizontal pixel count. Another new type of CCD has hexagonal photosites which are larger in area than square ones, and slanted at a 45-degree angle instead of being positioned head-on. Thus, more surface is exposed, capturing more information-per-pixel in both the horizontal and vertical planes, and allowing some "prosumer" model cameras to exceed 6 million pixel resolution.

3 Technical Issues

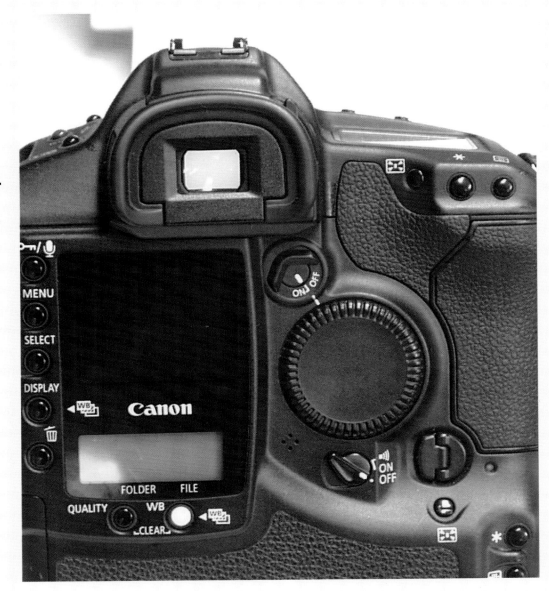

Digital Versus Film

HOW DIGITAL IMAGES COMPARE WITH FILM

Our eyes are used to seeing reality represented in many different media: television, videotape, movies, photocopies, digital images and still photography. Each one has its own characteristic that imparts a unique quality to the information we receive. The visionary writer Marshall McLuhan proclaimed that "the medium *is* the message." It is quite obvious, for example, whether a television program is being broadcast live from a studio or from film footage, just from the tonal balance of the picture. film lacks detail in the shadows and highlights, but seems to have a much richer mid-tonal range; video is crisp, but somehow flat by comparison.

But with digital and film still photography there seems to be a less obvious difference. Which is better? There are technical differences that can be measured, but the criterion of quality is subjective.

HOW CAN YOU TELL IT'S DIGITAL?

Differences in film and digital photography are subtle. The enlargement on the left is from a digital camera image; the one on the right is from a Kodachrome print, scanned on an Agfa Arcus flatbed scanner.

Here are some characteristics of digital photography to watch for:
- A more even tonal range, less contrast
- Less color saturation
- A faint aura around edges where contrast is greatest
- A slight "stair-stepping" on diagonal lines

❶

❷

Comparing quality
A photo from a digital camera (Olympus 600L) **1**, and a scan of a print from a 35 mm film camera (Pentax Spotmatic) **2**, are comparable in overall quality.

Digital photo characteristics
Although the resolution of most self-contained digital camera images is still relatively low, their tonal range, color accuracy and general realism is excellent. With computer software, graphic effects like this border treatment are easy to achieve.

FLEXIBILITY

film photography has to be concerned about different film types, color temperature, reciprocity (compensation for long exposures) and the chemistry of development. In contrast, digital photography tends to be more forgiving by virtue of its direct linkage to the computer, where image editing takes place.

STORAGE

Your digital camera, being linked to a computer system, can take advantage of an organized, hierarchial storage system that is both compact and (usually) reliable. Permanent storage media, such as CDR, are compact, convenient and inexpensive.

SOME DISADVANTAGES OF DIGITAL PHOTOGRAPHY

Hidden costs
The most obvious drawback of digital photography is that you need a computer. While computers today are almost as ubiquitous as television sets, for those who do not already own a computer, making the switch to digital photography—including the added expense of a computer, software and time to learn how to use it—might not be worthwhile. Add in the cost of an inkjet printer, paper and cartridges, storage media and peripherals and your digital option starts to look even more expensive.

Delay between shots
When a film camera takes a picture it produces a *latent image*, an exposed frame of film to be processed later. The exposure takes only a fraction of second, and several exposures can thus be made in rapid succession. However, a digital camera has to do its "processing" all at once: reading the light levels of millions of photosites, analyzing the data and writing it to memory. In some digital cameras this can take five seconds or more, making it harder to capture fleeting facial expressions and actions.

The LED is not a viewfinder
The LED or *light emitting diode* screen is a feature on most digital cameras, mounted on the back of the camera, or on a hinged panel. Many cameras display what the lens is seeing before the picture is taken, as well as showing the captured image for a few seconds. But the LED produces a rather jerky image with inaccurate colors that shift when viewed from different angles. Holding the camera at arm's length to frame a shot can be awkward, and in bright sunlight an LED screen is almost invisible. Continuous use of LED screens rapidly drains batteries.

ADVANTAGES OF DIGITAL PHOTOGRAPHY

One of digital photography's most obvious advantages is its "instant replay" capability. There's no processing time, and, if you have a laser or inkjet printer, you can make your own prints at any time.

While at the time of writing there are relatively few self-contained cameras that can match the resolution of 35 mm film, the image quality of most digital cameras is good and rapidly improving. In general, digital photographs have good representation of tonal range and excellent color accuracy. Some of the many practical benefits include reusable media, flexibility and computerized storage.

REUSABLE MEDIA

All electronic devices for recording images work with reusable media. A video camera, for example, records to a tape that can be erased and reused. The problem with analog media, such as tape, is that the quality of the recording degrades every time it is reused. Moreover, tapes eventually wear out. Loss of quality also occurs during duplication.

Digital cameras use digital storage media that can be erased and reused without any loss of quality. Your camera comes equipped with a lifetime supply of free "film."

SPONTANEITY

Digital photography engenders experimentation and originality. Because one can never "waste film" with a digital camera, there are no restraints on taking pictures spontaneously. If the image idea does not work, erase it and try something else.

Resolution and Memory

HOW MUCH RESOLUTION DO YOU NEED?

The critical factor in digital image quality is resolution, which is determined by the number of pixels in an image. Other camera features, such as optics, ergonomics and compactness are somewhat less important. Generally speaking, the more pixels it can record at once the more expensive the camera. Most digital cameras that are capable of producing images of more than 4 million pixels can also make lower-resolution photos. Since smaller photos use less memory, you can record far more of them on your storage medium.

PRINTING VERSUS SCREEN DISPLAY

Resolution requirements for a printing press, which are typically at least 250 pixels per inch, are high compared to a computer or video screen, where 72 and 96 pixels per inch are the standard.

Inkjet printers, on the other hand, are capable of producing acceptable prints at resolutions as low as 150 pixels per inch.

AVAILABLE IMAGE SIZES

Current digital cameras produce images from less than a megapixel up to six megapixels and more. While a four megapixel camera may be affordable, it might be excessive resolution if your main purpose is to make 8 × 10-inch prints. A glance at the table opposite will help you decide how much resolution you need for your camera.

INTERPOLATION

Some cameras use interpolation—digital enlargement—to obtain a larger format. Although interpolation increases the number of pixels in an image it does not increase its resolution. Digital zoom, which uses the camera's electronics, rather than the lens, to enlarge the image is another form of interpolation.

RESOLUTION AND IMAGE SIZE

The resolution of an image is normally given in terms of pixels per inch. Each digital camera produces images at a specific resolution determined by the manufacturer: for example, some digital cameras make images at 72 pixels per inch, others at 144, 150 or 180. This is somewhat misleading. Since a pixel can be enlarged or reduced to any size, it is the absolute number of pixels in an image, not the number of pixels per inch, that determines the image quality. Thus, a 24 × 18-inch image at 72 pixels per inch contains the same number of pixels as a 12 × 9-inch image at 144 pixels per inch.

COMPARING RESOLUTIONS
Digital camera images at three resolutions:
1 0.3 megapixels,
2 1.4 megapixels and
3 5.7 megapixels, scaled at 300 pixels per inch and printed in this book by offset lithography at 150 halftone dots per inch. *Photos by Jan Deligans.*

Image interpolation
Digital zooming virtually spreads apart the matrix of pixels captured by the photosites. Interpolation fills in missing information by averaging the differences between neighboring pixels. The resultant image is larger, but blurred compared to an image at twice the optical resolution.

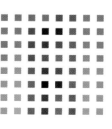

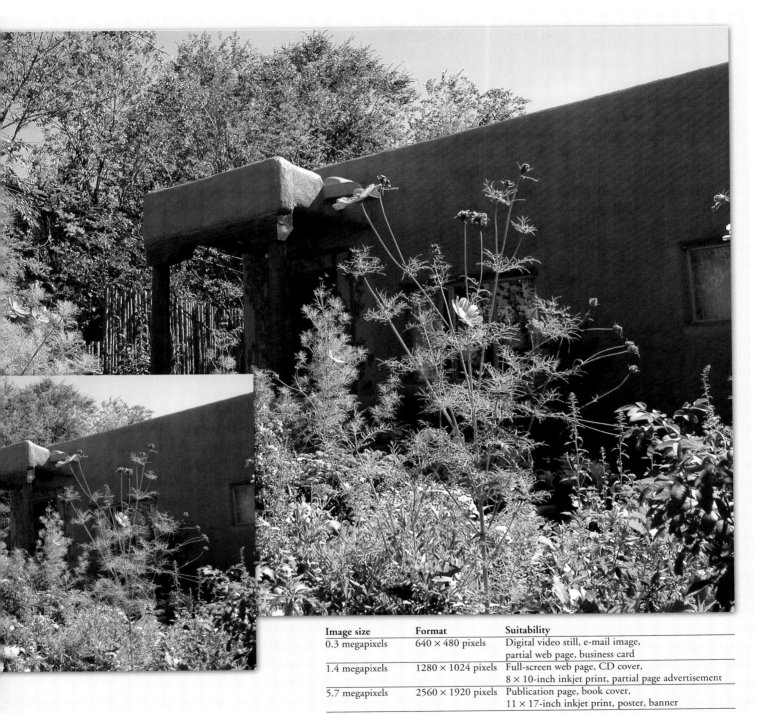

Image size	Format	Suitability
0.3 megapixels	640 × 480 pixels	Digital video still, e-mail image, partial web page, business card
1.4 megapixels	1280 × 1024 pixels	Full-screen web page, CD cover, 8 × 10-inch inkjet print, partial page advertisement
5.7 megapixels	2560 × 1920 pixels	Publication page, book cover, 11 × 17-inch inkjet print, poster, banner

HOW MUCH MEMORY DO YOU NEED?

When a digital photograph is taken it is stored temporarily within the camera, either in the camera's internal RAM or on removable media. With internal memory, once the camera is full,

STORAGE MEDIA CAPACITY

AVERAGE NUMBER OF IMAGES PER MEMORY CARD AT VARIOUS RESOLUTIONS

MEDIA CAPACITY	IMAGE SIZE IN MEGAPIXELS, HIGH/LOW COMPRESSION				
	0.3 low	3.1 high	3.1 low	4.8 high	4.8 low
8 megabytes	77	15	7	6	0
16 mb	155	30	15	12	1
32 mb	310	60	30	24	3
64 mb	620	124	60	48	7
128 mb	1240	248	120	96	14
256 mb	2480	496	240	192	28
512 mb	4960	992	480	384	56
1 gigabyte	9920	1984	960	768	109

MEDIA TYPE	MAXIMUM CAPACITY IN MB	
Linear flash	32	
SmartMedia	128	
MCM Card	128	
MemoryStick	128	
SC Card	256	
Type 1 CF	512	
CF2	1000	
MicroDrive	1000	
ATA flash	2000	
PCMCIA HD	5000	

no more pictures can be taken until the stored images are erased after downloading to a computer. With removable memory, one may continue to take pictures after filling the memory to capacity merely by inserting a new card or disk.

The amount of memory a photo occupies depends on the resolution and complexity of the image. A seascape on a foggy day, for example, will use less memory than a colorful street scene. A camera with an internal RAM capacity of 8MB can store up to 16 images at 1280×960 pixels resolution.

REMOVABLE MEMORY DEVICES

Removable memory has the obvious advantage of extending the available capacity of the camera indefinitely. Like film in a conventional camera, removable memory enables one to reload and continue shooting. Unlike film, removable memory can be erased and reused.

Removable memory systems include the ubiquitous and inexpensive 1.4MB floppy disk, the SmartMedia card and the Compactflash card. (See the table at left.)

FLOPPY DISKS

floppies have a limited capacity and make the camera rather bulky. Moreover, they are currently being phased out as a storage medium, and many computers no longer read this type of disk.

SMARTMEDIA

You can keep a large number of the lightweight, wafer-thin SmartMedia cards in your pocket or camera case while on a photo safari. They are reliable and relatively inexpensive. Their capacity range 8–128MB is relatively limited compared to Compactflash.

COMPACTFLASH

Compactflash memory cards are widely used and extremely reliable, ranging from 8 to 200MB in capacity.

POWER SUPPLY

Digital cameras consume much more electrical energy than conventional cameras. New owners of digital cameras will be shocked to discover that four AA batteries may scarcely last long enough to fill the camera's memory once, especially if flash is used.

BATTERIES

Rechargeable batteries and a battery charging unit are therefore an essential accessory. Two sets of batteries are required: one to operate the camera while the other is recharging.

PLUG-IN DEVICES

Another useful accessory is an AC adapter and power cable. The external power supply can be used to conserve batteries while images are being downloaded. The adapter can also be used when shooting indoors, although its dangling umbilicus limits mobility and is liable to cause accidents, injuring both camera and photographer.

OTHER ACCESSORIES

It's worth investing in a tripod if you don't already own one. Almost any model will suffice for still photography. (Videography requires an expensive fluid head for smooth panning.)

The neck straps that come with many digital cameras are often flimsy and difficult to install. Sturdy replacements are recommended.

A card reader is an essential accessory to save wear on the camera and expedite downloading. Many will accept both SmartMedia and Compactflash memory cards.

Storage media
1 floppy disks are bulky but cheap. Most digital cameras accept Compactflash **2**, or SmartMedia removable memory cards **3**. A card reader connects to the computer for rapid downloading **4**.

Power supply
5 A high-capacity removable battery with charger unit **6**, can provide power for several hours. **7** Standard rechargeable nickel-metal hydride batteries might last only long enough to shoot one card. **8** An AC/DC adapter is useful for desktop camera operation.

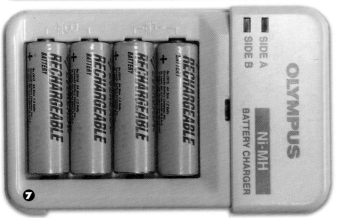

Exposure and Focus

Using available light
These uncorrected digital images were taken under various available light conditions. **1** A hand-held interior shot in daylight is not unpleasantly blurred, **2** On a performance stage with spotlights the blurring is due to subject motion. **3** Sunlight filtered through foliage gives maximum color saturation. **4** Bright sunlight makes bright colors and deep shadows.

LIGHT REQUIREMENTS

The light sensors in a digital camera have a somewhat broader range of sensitivity than any one type of film. This means that a digital photographer can take pictures under almost any lighting conditions without having to use a supplementary light source. Most digital cameras have an automatic exposure system that will not permit pictures to be taken if there is not enough light.

NATURAL LIGHT

Most pictures will be successful under any available light setting. The light levels for interiors in daylight, bright sunlight, overcast and twilight lie well within the gamut of automatic exposure controls of most self-contained digital cameras. When working with extremely low light levels the automatic exposure will select a shutter speed that is very slow. Camera motion and subject motion will cause blurring. Under these conditions it's a good idea to use a tripod, or support the camera on a fence, shelf or tabletop.

Digital

400 ISO

200 ISO

100 ISO

25 ISO

Light level

Exposure latitude
Digital cameras have a broader range of sensitivity than typical film types.

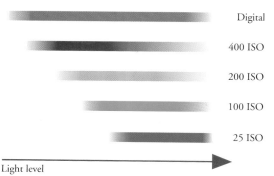

CONTROLLING THE EXPOSURE

The camera's automatic exposure system takes a reading over the entire image area and averages it. This works well under most circumstances, but if most of your picture consists of a light sky background, for example, the objects in the foreground will be underexposed.

Many cameras have a special setting or menu option that allows you to aim at a specific area of the picture where you want to optimize the exposure. This technique, called *spot metering*, is particularly useful whenever subjects are backlit, or surrounded by backgrounds that are either very dark or very light.

CONTROLLING THE FOCUS

Consumer-class digital cameras normally include automatic focusing as a feature. (Professional models allow for manual focusing.) Automatic focusing is a sophisticated technology that senses the amount of contrast and adjusts the focus to maximize it. The automatic focus system ensures that at least part of the image will always be sharp and eliminates the risk of missing a great shot while fiddling with a manual focus control.

A digital camera's automatic focus system assumes that the center of the frame is the desired point of focus—a reasonable guess in most cases. But when the center of the frame is *not* the subject of the picture, automatic focus can defeat its own purpose. You can override the autofocus by first aiming at the subject of focus with a partially depressed shutter button, re-aiming, and pressing the button all the way to complete the shot.

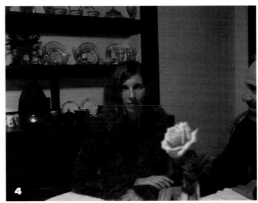

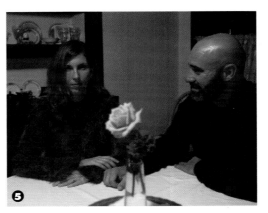

Using selective focus
The camera's automatic focus is selecting the flowers in the foreground, **3** thus, the couple is out of focus. When the camera is aimed at the woman's face, **4** she is now in focus, but the man is out of the frame. Swinging the camera back to its original aim point *while depressing the shutter button half-way* locks the focus on the people **5**. A successful shot can now be made by fully depressing the shutter button.

WHEN TO USE FLASH

A professional studio photographer relies on flash light sources inside "soft boxes" or bounced off reflective umbrellas. The results are stunning. But a photographer working with a self-contained digital camera is saddled with a flash unit that is attached to the camera itself—not the best position for a light source.

A digital camera can be set to use flash always, never or when there is insufficient light. flash photos are characterized by harsh lighting and dark shadows. There are times when the light conditions will not permit a photograph without flash, and the camera may stubbornly refuse to take a picture if the flash is turned off. You can get good results when working with a built-in flash if you are careful to avoid situations that exacerbate the stark quality of flash images.

Capturing details with flash
flash can bring out details, such as cats' whiskers, that are not salient in natural light. flash snapshots work best when the subject is not looking directly at the camera and is well clear of walls and backgrounds.

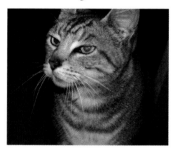

Using flash professionally
Professional digital photographers use flash attachments, which are positioned several inches away from the camera axis and can swivel to bounce light from the ceiling to avoid unflattering shadows. *Photo by Michael Price.*

DON'T GET TOO CLOSE

Being too close to a subject with the flash will overexpose it. Stay at least four feet away. Never use flash with close-up focusing.

STAY AWAY FROM WALLS

The light from the flash bulb casts a deep, sharp shadow. A person or object next to a wall or background will appear to have a dark outline on one side. In the middle of a room the light fall-off creates a dark background with no distracting shadows.

AVOID HEAD-ON SHOTS

Light from the flash is reflected directly back to the camera from the eyeball, causing an unnatural glare know as "red-eye." Many cameras have a special setting that causes the flash to fire twice: once to constrict the pupil and a second time to take the picture. Red eye settings reduce the glare, but you can avoid the problem altogether by shooting slightly to one side of the face.

CORRECTING RED-EYE

Elements comes with a handy tool for correcting "red-eye" in flash images: the Red-Eye Brush tool.
Here's how it works:
1 first zoom in on the image so that the eyeball is large enough to fill the working window. **2** Select the Red-Eye Brush from the tool palette. Then place it over the reddest part of the eye. **3** Now click the Current/Replace menu in the toolbar above to select a more natural color, either using a default color or specifying your own. **4** finally, paint onto the eyeball with the Red-Eye Brush. Only the offending red color will be changed.

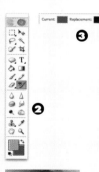

Working with Your Computer System

DOWNLOADING IMAGES

Once the pictures have been taken they are ready to be downloaded to a computer system. If the pictures have been stored on a number of separate removable memory cards, you will need to insert each card in turn into the camera, or in a card reader. Unless your camera has a very high-speed connection it would be wise to invest in a relatively cheap memory card reader. If you have an AC adapter it's a good idea to use it during downloading to save the batteries.

WORKING WITH YOUR CAMERA SOFTWARE

Image downloading software is usually provided with the camera. However, it may not be necessary to load extra software to connect to your camera, since operating system utilities and Photoshop/Elements provides the same function.

Your first view of the images will probably be in reduced size, spread out before you on the computer screen like a contact sheet. You may select all of the images, or pick out individual images from this screen for downloading.

INTEGRATING THE DIGITAL CAMERA AND COMPUTER SYSTEMS

The camera **1** is connected by USB or fireWire cable to the computer **2**, or removable memory inserted into a card reader **3**. From the downloading software, images are saved on a removable disk **4** or hard disk **5**. The printer **6** can also print individual images or index prints of all the frames from the camera. Permanent long-term storage media, such as CDs **7**, preserve the images.

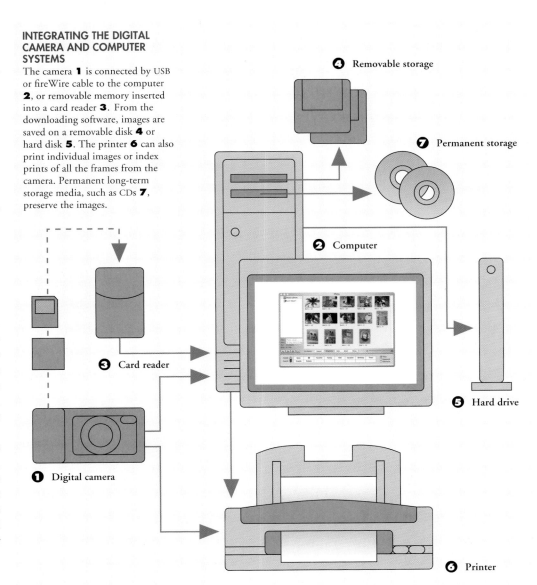

4 Removable storage

7 Permanent storage

2 Computer

5 Hard drive

3 Card reader

1 Digital camera

6 Printer

KEEPING TRACK OF IMAGES

Computer software offers a variety of ways to sort, categorize and store digital photos.

PROPRIETARY CAMERA SOFTWARE

Almost every digital camera sold comes with special software that is designed to help download, preview and organize your images. A typical camera utility presents a thumbnail view of all the images on the removable memory card and supports importing and deleting files. Many also provide for image rotation, basic tonal and color correction. Camera software may not always be compatible with your computer, however.

OPERATING SYSTEM SOFTWARE

Useful image browsing utilities are often bundled with computer operating systems: Windows XP Scanner and Camera Wizard and Apple's iPhoto are two popular examples. In addition to viewing and downloading images, they provide for rotation, image correction and database functions, as well as printing, slideshows, and e-mailing.

PHOTOSHOP/ELEMENTS BROWSER

Elements/Photoshop's Browser function (File > Browse) opens a window that displays all the images on a memory card with information about each image. files may be rotated, renamed and opened for immediate editing. Another feature creates printable contact sheets (in Photoshop: File > Automate > Contact Sheet II; in Elements: File > Print Layouts > Contact Sheet).

Using browser utilities
1 Apple's iPhoto is an example of a digital image browser that is part of a computer operating system. It creates an image database with user-defined categories. It can also rotate images and execute basic tonal and color balance corrections. Output features include slide shows, photo albums, e-mail and web pages.
2 Elements/Photoshop's Browser mode (File > Browse) gives immediate access to all the exposures on digital camera memory media. You can easily rotate and rename files. Clicking on a picture launches it in a window for further editing. **3** Photoshop/ Elements will also create contact sheets, which can be printed and collected for future reference.

4 The Big Picture

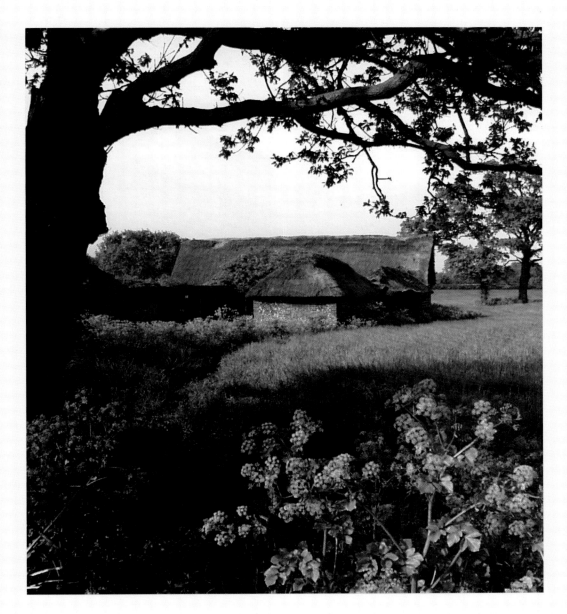

Environmental Photography

WORKING WITH NATURE

The natural world in all its diversity is perhaps the most enjoyable subject for photography. Whether you're taking a walk in a local park or forest, or a road trip covering thousands of miles, it pays to take your digital camera along. While no match for Ansel Adams' glass plates, a digital camera can still take excellent landscapes that capture the presence and atmosphere of an outdoor location with amazing fidelity.

Your chances of capturing some great images are improved by considering certain criteria as you shoot. Here are some of the things I like to keep in mind as I'm taking digital photographs of landscapes and natural environments:

Be on the lookout for the unusual, the unique. When you go to a new location, capture your first impressions. What at first seems unusual will rapidly start to look familiar, and you may miss some wonderful shots.

The sky and clouds are an important element of your image. No matter how wonderful the scenery, a plain blue sky can make your picture look boring, like a stock postcard.

Seek out simplicity. Favor bold, clear lines of composition that define dramatic shapes, or limited numbers of colors.

Watch for contrasts: the contrast between the delicate flow of a creek and the ruggedness of the surrounding rocks, or even the contrast between the beauty of nature and the ugliness of what humans have done to it.

Photos of distant views often look flatter and less dramatic than they seem in real life. Including a foreground detail helps. A nearby rock provides a visual link to the mountain in the background.

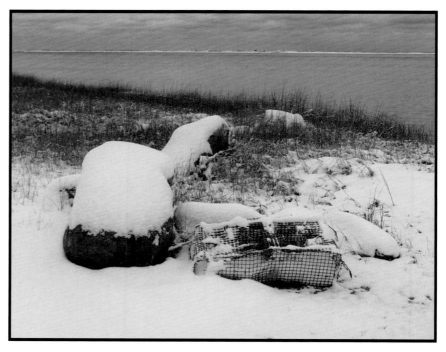

Capturing an environment
A calendar layout based on digital photography from a Southern California desert.

Foreground interest
A desolate Cape Cod shore in winter is made more interesting by including some snow-covered lobster traps in the foreground. A high horizon crops out a featureless sky, and the diagonal shoreline leads the eye from the foreground to the distant fishing sheds, adding a sense of depth.

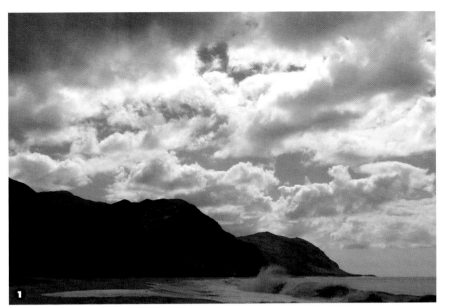

Using skies, contrast, depth and simplicity in landscapes
1 Without the clouds, this would have been just another sunny Hawaiian postcard. **2** A backlit rock formation from the Laguna Mountains combines bold, rhythmic shapes with undulating textures. **3** The yellow wildflowers on a Big Sur cliff-top contrast with the misty shore below and add depth to the picture. **4** The horizontal layers of blue, green, white and brown of the Del Mar beach evoke the simplicity of a minimalist painting.

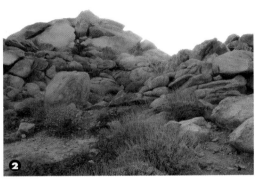

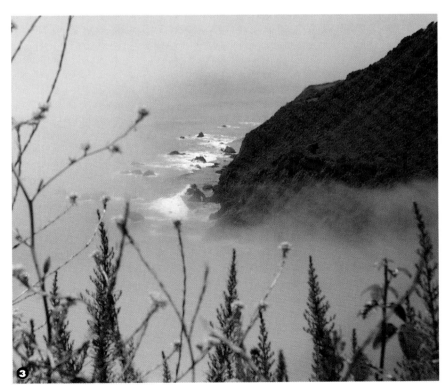

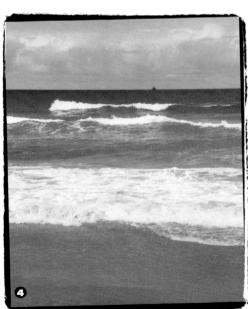

CAUTION: I BRAKE
FOR SCENERY

Photography is opportunistic—success depends on being at the right place at the right time. Carrying a digital camera with you at all times increases your chances. When traveling with your camera you may encounter some amazing transitory phenomena: the play of light on a hillside on a cloudy day, a fiery sunrise over a calm lake.

Atmospheric effects are fleeting, and trying to take good still pictures from a moving vehicle is not recommended, nor is attempting to shoot and drive at the same time! So warn your passengers to be prepared to stop.

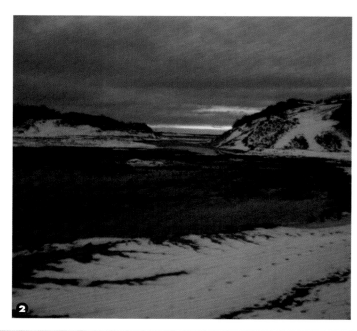

Fleeting moments
1 The incredible sliver of intense orange light piercing the gloom of a Cape Cod beach at twilight disappeared after a minute. **2** The elusive disk of the afternoon sun is visible over a fog-enshrouded central California marshland.

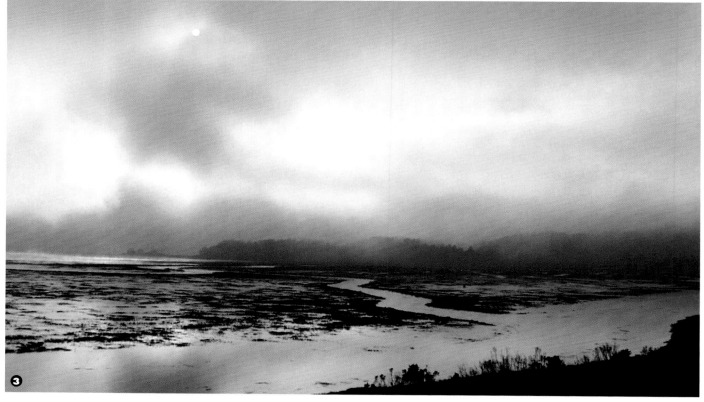

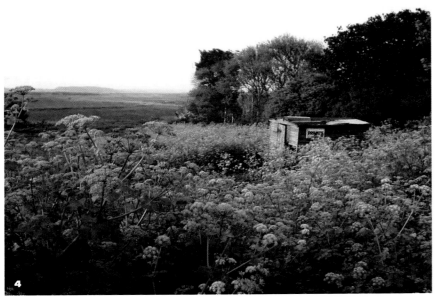

Changing light quality
4 The digital camera captures the lush greens of an East Anglian coast landscape during the long spring twilight. **5** The almost vertical angle of midday sunlight throws a deep shadow on a rock-face and picks out the surrounding foliage in vivid colors.

ON THE ROAD: THE PROPERLY OUTFITTED TRAVELING DIGITAL PHOTOGRAPHER

A fishing or safari vest makes a handy clothing item for digital photography expeditions. Accessories such as memory chips and rechargeable batteries are readily accessible in the vest's various pockets. For a woman, a large purse or handbag may suffice, but there should be clearly differentiated compartments or inner pockets to segregate the used and unused memory cards or disks. Of course, "fanny packs" are appropriate for either gender. Most digital cameras are too large to fit into pockets, and will have to be carried around the neck or shoulder. Straps provided by most digital camera manufacturers are flimsy. I recommend replacing them with a sturdier strap.

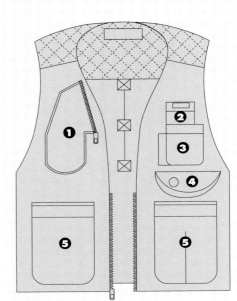

1 Spare batteries
2 Unexposed memory
3 Exposed memory
4 Camera accessories, lens caps
5 Bulkier items: battery chargers, lens attachments

PANORAMAS

Sometimes the scope of an environment is far too much to be represented adequately in one photograph, so a number of photographs can be shot in sequence, then pieced together on the computer into a panorama. Fortunately, digital technology makes this task a lot easier than it was in the old days of scissors and glue.

SETTING UP YOUR PANORAMA SHOTS

The best way to make a horizontal panorama is to place your digital camera on a tripod, making sure that the tripod is level. Each exposure should have a certain amount of overlap, but not necessarily any precise amount. While you are shooting you will be using human short-term visual memory: for example, the tree at the right edge of frame 1 should appear again at the left edge of frame 2. (Some cameras provide guides in the viewfinder to help calculate the overlap.)

Even if you don't have a tripod, you can still make a successful panorama. There will be more vertical displacement of the image, and you may lose some foreground and sky when the assembly is finally cropped.

RESOLUTION

I recommend using 640 × 480-pixel resolution for panoramas. The lower resolution may well be more than adequate if you are planning more than three or four shots. If your camera's maximum resolution is 640 × 480 pixels, then panoramas are an excellent way to obtain higher resolution photographs.

MAKING A PANORAMIC MOSAIC IN SOFTWARE

Photoshop and Elements enable multiple images to be placed on separate layers. This allows them to be manoeuvred individually to obtain precise alignment.

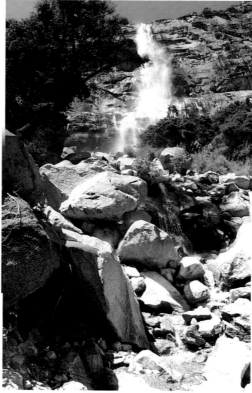
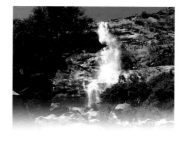

Making a vertical panorama
Three horizontal photos have been overlapped to form a vertical composition. The technique involves aligning each image on a separate Photoshop/Elements layer, selecting the horizontal edges and applying *feather* to the selection (Selection > Feather).

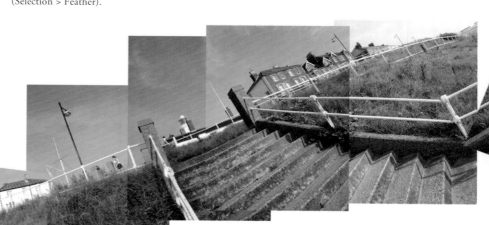

ASSEMBLING A PANORAMA IN PHOTOSHOP ELEMENTS USING PHOTOMERGE

Photoshop Elements provides a clever, semiautomatic way of assembling a panorama. The program does not care whether the sequence was shot left to right or right to left, or even if the shots are numbered sequentially. However, there must be an overlap of no less than 15% and no more than 40%. The camera must be held level, no distorting lenses used, and flash used either throughout the sequence or not at all.

To create a Photomerge composition, choose File > Create Photomerge. Use the Browse windows to navigate to your panorama sequence files and click Open. The program makes an artificial intelligence guess about how the pieces fit together and displays the results in the Photomerge window. If the sequence appears to be scrambled you can easily drag apart the pieces and reassemble them. The snap-to button, when enabled, aligns the segments automatically.

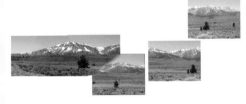

When you are satisfied that the pieces are correctly aligned, click OK. Selecting Advanced Blending corrects the exposure differences between individual images in the panorama.

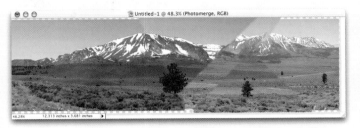

Initial Photomerge assembly with misplaced parts

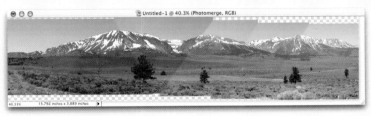

Corrected sequence

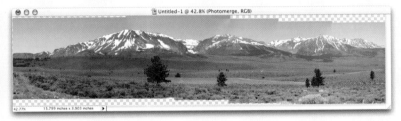

Corrected sequence with Advanced Blending

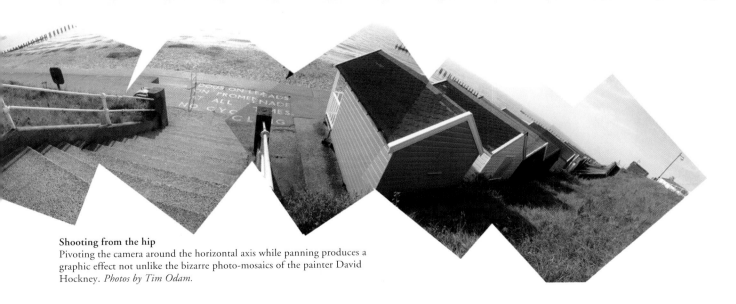

Shooting from the hip
Pivoting the camera around the horizontal axis while panning produces a graphic effect not unlike the bizarre photo-mosaics of the painter David Hockney. *Photos by Tim Odam.*

Capturing Light, Shade and Color

SETTING THE WHITE POINT

The color temperature of the ambient light can significantly alter the appearance of things. A white sheet of paper, for example, photographed in candlelight, will appear yellow—even though it looked white in the viewfinder. Our eyes automatically adjust to variations in color temperature because our brains compensate for it. If you were to spend some time inside a green tent, you will discover that the sky has turned pink outside. Digital cameras, too, have ways of compensating for variations in ambient light color. Some cameras have settings that correspond to the daylight and tungsten film used in conventional cameras. With many digital cameras, as with scanners and digital movie cameras, the *white point* of an image can be established by aiming at a white object and registering its color value

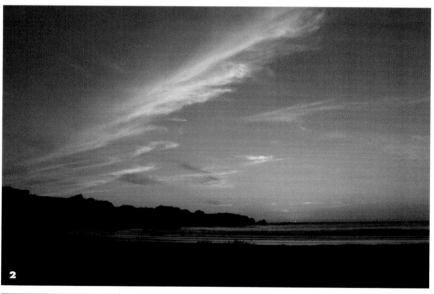

White point settings
1 An automatic white point setting ensures that a white lighthouse looks white in any light condition. *Photo by Tim Odam.* Applying a white point adjustment to a sunset scene **2**, however, negates the dominant redness **3**. *Photos by Jan Deligans.*

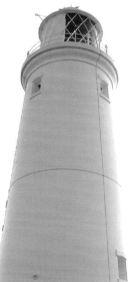

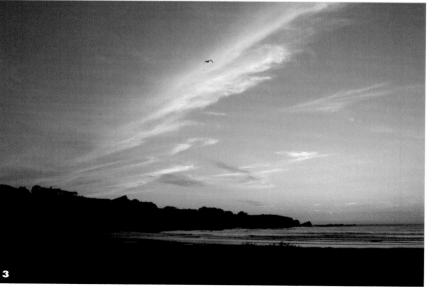

Observing light variations
A series of exposures at one-hour intervals beginning at 8 a.m. shows the subtle light variations in an English garden in summertime. *Photos by Tim Odam.*

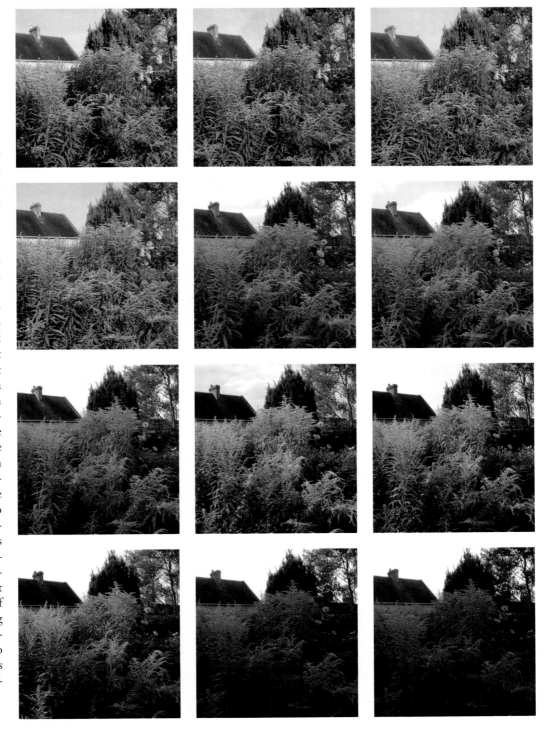

into the camera's temporary memory. Thus, when the photo is taken, the color and tonal balance will be calibrated with reference to that white object.

TIME OF DAY

Outdoor light varies in direction, intensity and color temperature throughout the day. These variations may be dramatic or quite subtle, depending on the part of the world and the season. In most cases, direct overhead light does not give best results. Oblique light creates a more attractive illumination with a better distribution of highlights and shadows. The one hour after sunrise (and also the one hour before sunset) is known as "the golden hour" in filmmaking. This should not be taken to mean that only two hours are available for photography in any day, but it suggests when the most dramatic pictures can be taken. Good pictures are taken at all hours, but it's a good idea to take time of day into account when planning a shoot. Even in overcast conditions, the light during the two hours around noon will be less attractive than morning and afternoon light.

Event Photography

GOING FOR THE ACTION

Covering an event with a camera can mean anything from hard-hitting photojournalism to immortalizing a child's birthday party. Digital photography offers the advantage of timeliness and ease of distribution via e-mail, web site or even a newspaper page.

Human events can be even more fleeting than atmospheric phenomena, and getting the timing right can be tricky. Many digital cameras have a dual-function shutter button to focus and calibrate the exposure when pressed halfway, and to take the picture when fully depressed. Some recent cameras, however, include exposure settings to facilitate action photography.

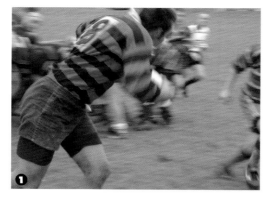

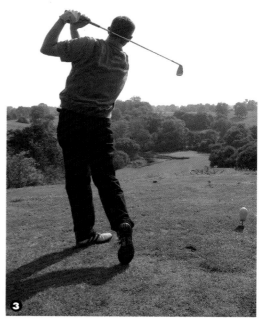

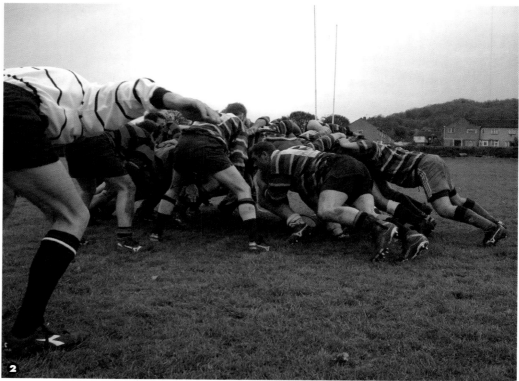

Covering the action from up close
1 Shooting from the touch line in sports mode (fast shutter/wide aperture) captured the atmosphere of a rugby match from the players' point of view. The multiple exposures setting guaranteed getting at least one good photo. **2** A low wide angle put the viewer close to the action. The lack of spectators in this amateur game allowed the photographer access to shots with a mid-range digital camera lens. **3** The same camera mode from a standing position was used to capture the end of a golfer's swing. *Photos by Tim Odam.*

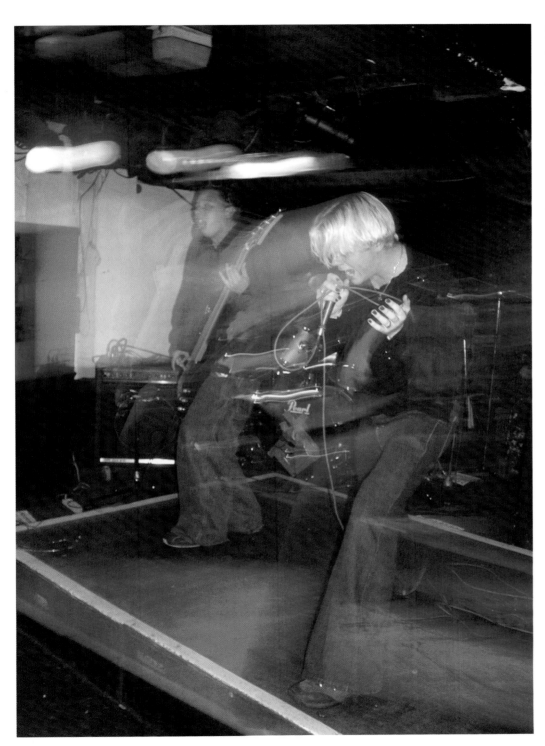

Capturing action with flash
To suggest the movement and sheer volume of this young rock band, the photographer used *trailing slow synchro flash* where the flash fires twice while the shutter remains open. The long exposure causes "ghosting" and image trails, yet the parts of the image frozen by the flash remain sharp. *Photo by Tim Odam.*

SCENE OF THE CRIME: IS DIGITAL PHOTOGRAPHY ADMISSIBLE AS EVIDENCE?

The camera does not lie, but it exaggerates, understates and equivocates. The circumstances might be relatively innocent (is that a flying saucer or a garbage can lid?), or there may be crucial legal issues at stake (is that suspect's car blue or green?). When you add to this latitude of interpretation the undetectable editing of digital images, any image in digital form should be questionable, if not inadmissible, as evidence. Notwithstanding, digital cameras are already in use by New York police for domestic violence investigations.

A case could be made, however, for using evidence from digital cameras: If a memory card or disk were to be removed from a camera and kept under strict custody, its contents could be admissible in evidence, since only a camera can write to the memory card. And a card cannot be tampered with without destroying the data.

SOCIAL OCCASIONS

Covering a planned social occasion such as a wedding or party with a digital camera has the advantage of making the pictures immediately available for viewing on a computer screen, or disseminated over the Internet. Since many social events take place indoors and at night, low light levels may require flash. If your camera has a remote flash attachment, consider bouncing the flash off the ceiling to avoid harsh shadows.

As the event unfolds in front of the camera, a good photographer anticipates the moment like a good surfer knows the right spot to catch the wave.

The photographer is there to capture, not manipulate, the event. Wedding photographers blend formal poses with reactive, candid interactions and storytelling details.

Shooting from above the fray
The photographer had already taken some 30 shots by the time he captured this image, so the kids were no longer aware of his presence as he stood on a chair overlooking the birthday party feast. The high camera angle and the selection of black and white reveals the detail of a cluttered tabletop. Light falling from roof-level windows added depth to the objects on the table and eliminated the need for flash. *Photo by Tim Odam.*

Shooting weddings

1 Formal portraiture does not have to be stiff. **2** Natural light is more flattering and gives greater depth. **3** The colors of a bridesmaid's bouquets can evoke vivid memories long after the original flowers have withered. **4** A lucky shot with the camera held over the head reveals an intimate moment for the dancing couple. **5** Playful moments can occasionally be staged, adding to the spirit of celebration. *Photos by Michael Price.*

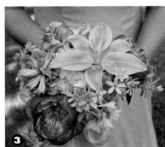

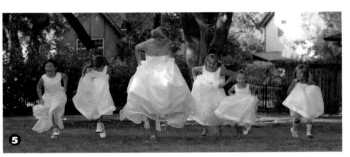

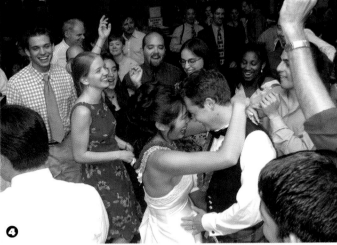

Using a mix of shots

To cover the entire event, ¾ of the photos should be unposed, documenting the action, ⅛ posed group and individual portraits, and ⅛ significant details— "scene setters"—such as the outdoor environment, decor, cake and floral arrangements.

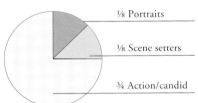

⅛ Portraits

⅛ Scene setters

¾ Action/candid

Location Shots

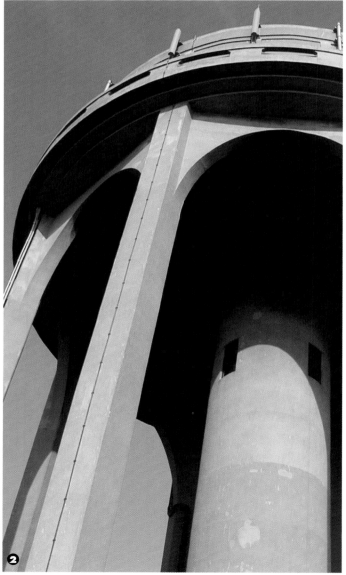

Photographing the awful
1 The conglomerations of directional signs that confuse motorists make interesting photographs. **2** The stark lines of a water tower are echoed by a play of shadows. *Photo Tim Odam.*
3 A Gothic-looking freeway interchange towers above a field of weeds.

THE GOOD, THE BAD, AND THE UGLY

Not all of us live in places full of great natural beauty. For the most part, our habitat may seem mundane—all too familiar. And as we travel, our journeys are as likely to lead us along bleak streets as well as scenic routes. But wherever we may be at any moment there is a potential picture. With a digital camera as a constant traveling companion, I have encountered so many intriguing locations both far from home and in my own neighborhood.

Really ugly places make great photographs: an abandoned freeway, a half-finished industrial monstrosity, a back alley lined with telephone and power lines. There is an odd beauty to be found in things that are utterly grotesque.

Sometimes an ugly photograph can invoke outrage. A maze of impoverished shacks on a hillside, for example, a prison watchtower or a polluted concrete-lined river demonstrate the power of the camera to stimulate emotions with strong visual images.

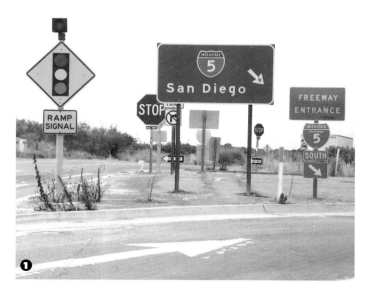

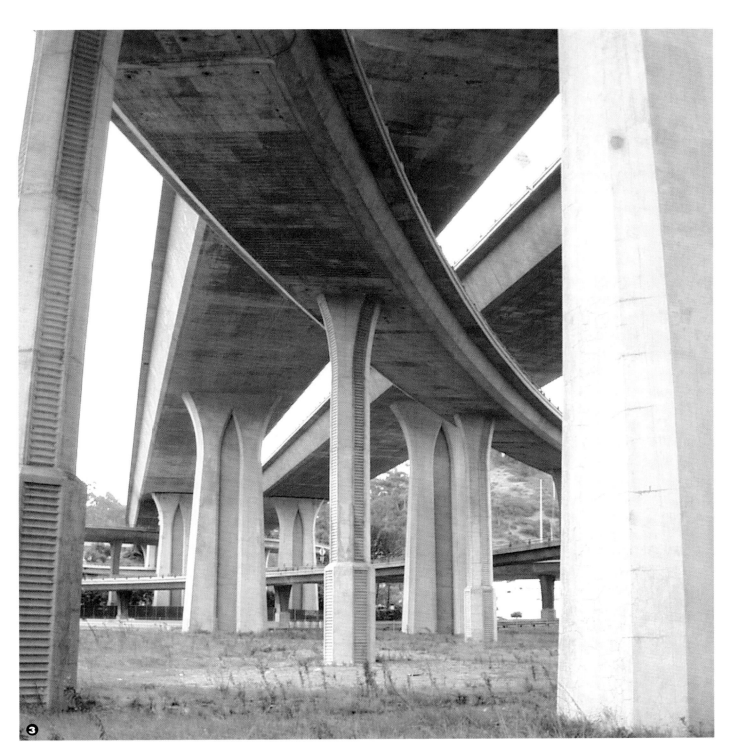

❸

Shooting from a different angle
1 An oblique camera angle captures the wooden figure and sign on a tall building on a narrow street. *Photo by Tim Odam.* **2** Viewed from a high-rise building, the shadow of an approaching cyclist intersects the pattern of palm trees and directional signs painted on the roadway.

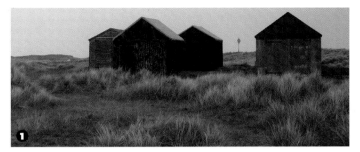

Shooting location details
1 Dune grass surrounds a row of
fishermen's huts on a windswept
shore. **2** Proud flags are framed by
the peeling paint of a window.
3 Precarious plants cling to an urban
balcony.

BUILDINGS AND ARCHITECTURE

Since we spend most of our lives inside and near buildings it's no wonder they shape our culture and lifestyle. Architectural exteriors and interiors present different technical challenges to the digital photographer.

EXTERIORS

Photographing a building from the outside is often made difficult by unsightly utility poles and lines. Using a narrow lens angle or zooming in minimizes distortion.

INTERIORS

It helps to expose for the interior light rather than light coming from windows. It may be necessary to use a wide lens angle or zoom out to include all the features of a room.

Focusing on angles
The unusual angular shapes and primary colors of this starkly modern wastewater processing plant make a strong composition.

Revealing details
The charm of old buildings is revealed in details: left, the gable of an East Anglian flint house; right, a wooded sculpture surmounting a bank in coastal Northern California.

Mailing a building
A postcard to promote a Realtor.

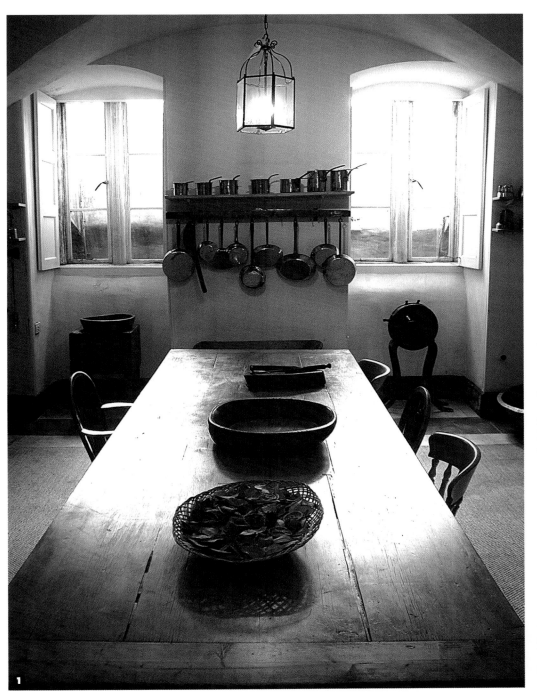

Photographing interiors
Diffuse natural light streaming
though the windows of a Southern
England country kitchen **1** is
reflected in the table, giving depth to
the composition. *Photo Tim Odam.*
Exposed overhead duct-work graces
an industrial passageway **2**, and worn
stone steps lead the eye into an
ancient cathedral **3**.

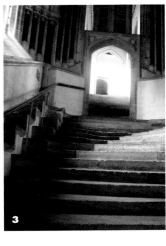

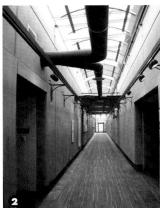

CORRECTING FOR PERSPECTIVE

There is a convention in photography that all vertical lines in buildings should be parallel, even though that is not actually how our eyes—and normal camera lenses—see objects. This notion of how buildings ought to look stems from the Renaissance, when the geometry of perspective was discovered, and is persistent today.

In traditional photography, perspective correction is achieved by using special cameras with independently movable lens and film mounts that are connected by bellows (see page 6). While it is possible to fit such cameras with a digital back, the typical digital camera has a fixed lens position and will produce images that do not conform to classical perspective. Perspective correction generally takes place after the picture is taken with image-editing software such as Photoshop.

Comparing ideal and camera perspective
1 The notion that vertical lines in buildings remain that way, regardless of how the object is viewed, is embodied in this conventional perspective drawing. **2** In the real world, as seen by the camera lens, horizontal lines converge at the horizon, and vertical lines converge directly overhead. Wide angle lens settings produce a further distortion in which straight lines appear curved.

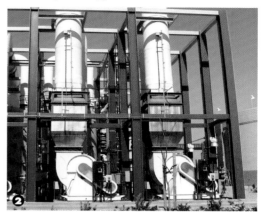

Correcting the perspective of an architectural interior
The gray margins of the photograph show how the four corners of the image have been repositioned to correct for perspective. After adjustment, lines are more or less vertical and horizontal.

Correcting an architectural exterior
3 In Photoshop/Elements, with rulers visible, drag out vertical guidelines to the building's sides. **4** Then Select All, and use the Transform, Distort command's corner handles to align the building's verticals with the guides. (See page 94 for another method for correcting distortion.)

5 Working with People

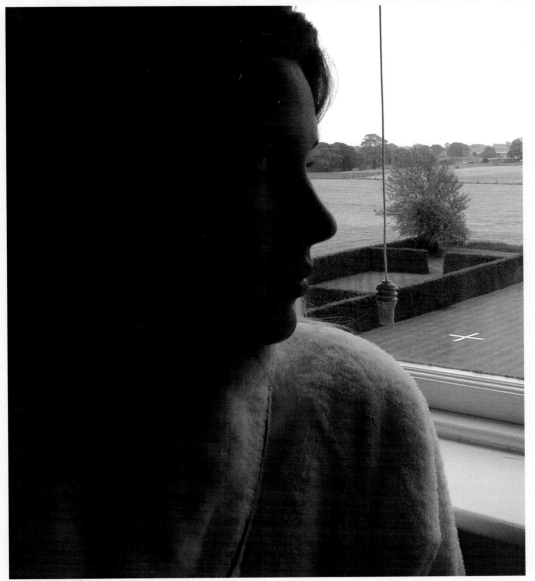

Photo by Tim Odam

Portraits

Using natural light for portraits
Natural light is often the best for portraits. The shaded overhang of a mission cloister on a bright spring midday provided diffuse lighting. The white adobe wall behind the models created a perfect backdrop.

LEGAL ISSUES

Unlike landscapes or still-lives, people are usually aware of being photographed and might be concerned about how the images will be used.

Pictures of family members and compliant friends are not an issue. Nor, of course, are photographs taken at the request of the subject. But photographing strangers in public places is a legal gray area—especially if you are close enough so that the person is obviously the subject of the image. People do not usually object to being photographed, but they should be asked, and street performers who are photographed should always be paid. You can often win approval by showing your subjects their image in the playback window of your digital camera.

Whether your model is amateur or professional it's a good idea to get a signed model release if your photograph is being put to any kind of commercial use. Professional photographers use model release forms. Sample forms can be obtained from the Photography Resource Center (www.netwrite-publish.com/ photography.htm).

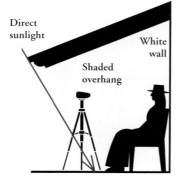

Direct sunlight

Shaded overhang

White wall

WORKING OUTDOORS

Direct sunlight should be avoided for two reasons: the harsh shadows are unflattering, and sunlight causes people to squint. This is why movie crews always use large diffuse reflector cards and umbrellas to fill in the shadows when filming people outdoors in sunlight.

LOCATION AND LIGHTING

When the sun is bright, a good location for outdoor portraits would be the exterior of a building with a generous overhang. Hazy sunshine, mist or fog are also excellent for portraiture. For best results, shoot toward noon. Early morning and late afternoon light casts long shadows and has a color imbalance, which can impair an outdoor portrait.

WORKING INDOORS

For more formal portraits it's more convenient to work indoors where you have control over the setting and the lighting.

AVAILABLE LIGHT

If your room has skylights or windows that face north, eliminating direct sunlight, you can make good portraits with available light, although the skin tones may be somewhat cool. The lower light level of the indoor environment will open up the aperture of the camera and trigger a longer exposure time. As a result, the image will have a diminished depth of focus and may be blurred by subject motion. A tripod, of course, is a necessity in this situation.

ARTIFICIAL LIGHT

You can transform a room into a portrait studio with just two incandescent lights, mounted on stands. In a standard lighting arrangement, the principal light is known as the key light, and is positioned in front of the model. Another light, the fill light, is positioned behind the model. A bounce card serves as a reflector to add detail to the shadow side of the face. (See the sidebar on this page.) Color correction may be necessary to overcome the yellowish cast of the incandescent lights.

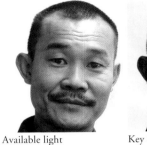
Available light

Key light only

Fill light only

Key light and fill light

SETTING UP A STUDIO FOR PORTRAITS

A typical setup for taking portraits indoors would include two lights and a reflector, usually a sheet of foam-core board. The key light **1** is in front of the model and off to one side, and the fill light **2** behind the model and diametrically opposite the key light, and the bounce card **3** on the other side of the model from the key light.

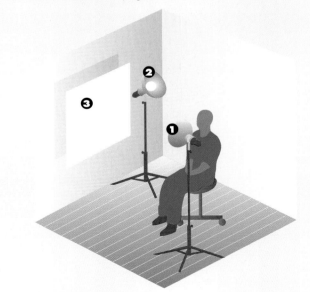

Key light, fill light, and bounce card

Full-Length Figures

Backlit full-length figures in an outdoor scene can be easily adapted to make graphic silhouettes.

STUDIO SETUP FOR FULL-LENGTH FIGURES

Full-length photographs of people require a different compositional approach than facial close-ups. A portrait cuts off the rest of the body at the shoulders, but a full-length shot creates a complete, self-contained shape. The body can adopt an infinite number of poses that generate wonderful graphic forms.

It's best to be about 10 feet away from the model, so you will need a fairly large room to get the whole person, head to toe in the frame. If you have a zoom lens, get even farther away if you can to minimize perspective distortion. Rotate the camera into the vertical frame position to fill the frame as much as possible for the best resolution. Have the model stand a little away from the wall to minimize shadows.

The lighting considerations for portraits apply equally to full-length figures. Backgrounds may

Using silhouetted figures
Full-length silhouetted figures make excellent spot illustrations for newsletters, flyers and editorial layouts. The clothing, pose, posture and outline shape of a figure silhouette make a strong graphic image.

include drapery or a paper roll—especially useful if you want to make the background drop out to white to make a silhouette.

MAKING SILHOUETTES

To make a silhouette you are probably going to be editing your photo to delete the background. You can waste a lot of time and energy trying to set up a background that reads as pure white against the figure when it's far easier to drop away the background with image editing. You will need a background that is light enough to give edge definition so that the picture can be edited easily.

Some widely used silhouetting techniques in Photoshop/ Elements include manually selecting the background with a Lasso tool and deleting it, or using a Magnetic Lasso to automate the selection. (See pages 79–81 for more on silhouetting.)

Many walls are white, but most floors are not. A roll of white paper can be pinned to the wall and allowed to fall freely to the floor, forming a gentle curve that hides the seam between floor and wall.

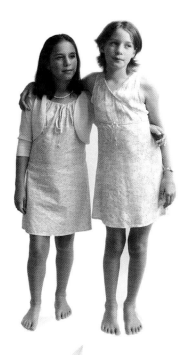

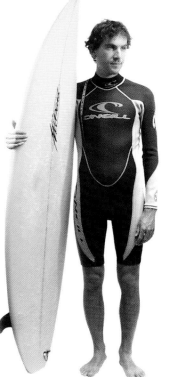

MAKING A LIBRARY OF BODY PARTS
Close-up digital photos of hands, eyes, ears and noses serve as useful graphic icons. They can be used to add interesting details to advertisements, catalogs, Web sites and book pages.

People in Context

BACKGROUNDS AND SURROUNDINGS

Removing a background from a photo of a figure creates a strong graphic shape, but often the surroundings tell us as much about that person as the facial features and expression. A posed contextual portrait combines elements of still and portraiture photography. An informal approach seeks subjects caught unaware or so engrossed in their activities as to be oblivious of the camera.

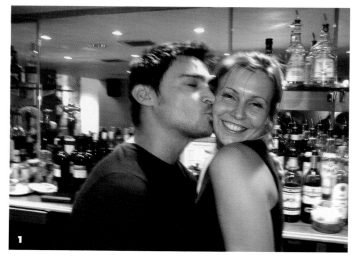

Capturing the context

1 A couple flirts for the camera. Shot using natural light and a high ISO setting, the slight movement in the image suggests a mild intoxication and softens the busy background of bottles, glasses and lights, focusing the eye on the action. *Photo by Tim Odam.*

2 A woman proudly displays her sponge cake, ready for afternoon tea.

3 Street musicians pause at a beachfront fruit stand, unaware of the photographer. The primary colors of the surroundings contrast with their dark clothing and white hats.

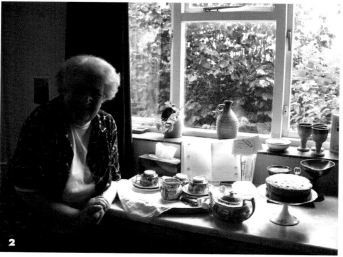

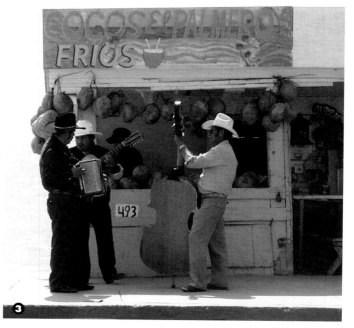

Portraying an artist at work
An illustrator completes his assignment while listening to jazz. The radio, the brushes and pens on the table add relevant detail, while the shape of a gooseneck lamp counterpoises the figure intent on his meticulous artwork.

People in Groups

ON LOCATION

Most group pictures happen on location where the group event or activity occurs—a meeting or a family gathering for instance. For logistical reasons, it is more practical for the photographer to travel to where the group is, rather than vice-versa. If you want informal group pictures, people always look more relaxed and natural on their home turf.

IN THE STUDIO

When a more controlled environment, perhaps with props, costumes and lighting effects, is needed, a studio setting works best. Studio photography is also more suitable for a formal group picture.

SOMEBODY BLINKED!

The more people there are in a group, the more likely it is that at least one member of the group will blink, grimace or otherwise present a less than perfect countenance to the camera. With a conventional camera, the easiest way to overcome the problem is to take a large number of pictures, rather like winning a raffle by buying a large number of tickets. With digital photography it's also wise to take many shots, but even if every group picture is fatally flawed it's relatively easy to combine images to patch together the best shot of each person. Of the many image editing techniques, the easiest is to select and "feather" a face, copy it, and paste it onto another image.

Shooting unposed groups
Some of the best informal group pictures are taken when people are preoccupied with what they are doing and are unaware of the camera.

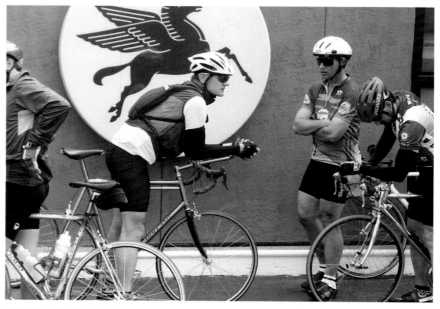

Splicing a face
1 Most of *Los Californios* look good in this shot, but Vykki blinked. **2** This shot is not so good overall, but Vykki's eyes are open. **3** I pasted a copy of her face from shot 2 onto shot 1 to make an optimal group photo.

REMOVING AND REPLACING PEOPLE

With the widespread use of sophisticated image-editing software, we are now living in an Orwellian era where people can be removed from photographs and replaced, thus altering history. In a more benign situation, a digital photograph can be easily doctored so that an absent member of a group can be photographed separately and spliced in. This method is a good alternative to using a self-timer when the photographer needs to be included in the picture.

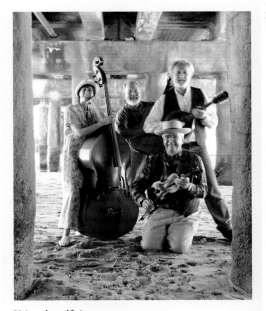

Using the self-timer—unsuccessfully
In a mad scramble to get into the picture, the photographer, wielding mandolin, mars with a blurry presence an otherwise good group picture.

Switching photographers and models
In setting up the first shot I had Jerry, left, stand a little apart from the others for two reasons: to leave space for me in the second shot, and also to make it easier to select him to make a composite picture. I then invited Jerry to take the second shot and stood behind Ed Jr., filling the space between him and Jerry.

Pasting a selection
To make a group picture with all four people I needed to combine the two photos. First I opened both photos in Photoshop/Elements. I used the Polygon tool to select loosely around Jerry's body, then I feathered the selection 10 pixels. Next I copied the feathered selection and pasted it onto the second photo, carefully aligning the foliage around Jerry's head and the steps behind him with the image in the layer below.

A gallery of family groups
1 Using a tripod in low light, the photographer kept the lens trained on the mother while the child who was rushing about came to rest only for a few seconds.

2 Two boys play with their handheld game consoles. The contrast of their black attire against a light colored carpet and the symmetry of the two boys assists the balance of the image horizontally and vertically. Large windows with net curtains diffused the light.

3 An aunt relaxes while her niece perches upon her knee. When people relax they become a digital photographer's easiest target. Use of black and white unifies the busy patterns in the shot. Light is falling from low windows left and right, and some low level interior table lamps. Spot focusing on the girl's face brings out the detail.

52

FAMILY GROUPS

Making natural looking photos of members of your own family often isn't as easy at it seems. Family folk tend to pose and show their "best side" when they feel a lens is upon them, especially when dressed up for an occasion. Helping people to feel at ease is more than half the trick to a good portrait, particularly where groups are involved. The more people in the shot the harder it becomes to get the right one, so always take more photos than you think you need—you can never run out of film!

Digital photography can help in your quest to reassure your subjects. Show them some pictures as you take them and allow them to help choose the kind of shot that they like. Their involvement in the process almost always increases your chances of getting the shot you need.

In general, avoid the use of on-board direct flash where possible. This not only adds harshness and flattens, it disturbs the subject. A bounced flash from an additional unit can, however, work well.

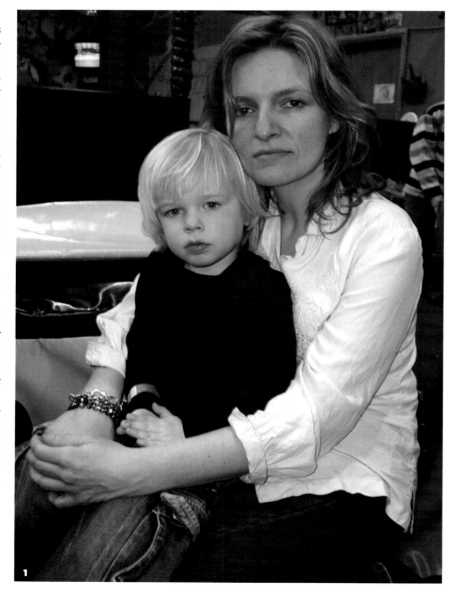

1

4 These children are used to the camera, and are easy to capture in an unposed shot. The contrast between the messy plates of food, the boys and the angular structures surrounding them makes a good photograph.

5 The child was distracted with a length of string, which he found more interesting than the lens, allowing the interaction between him and his mother to be captured. Bringing the camera down to floor level presents a more playful and intimate image. *Photos by Tim Odam.*

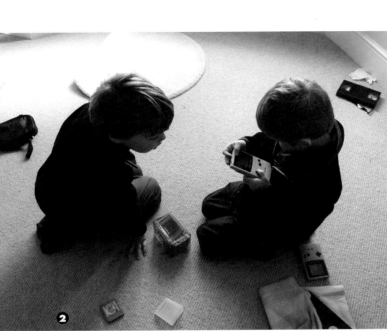

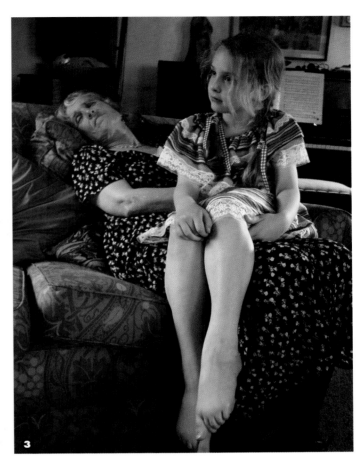

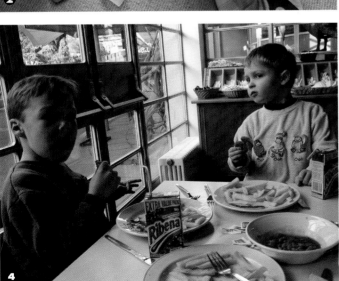

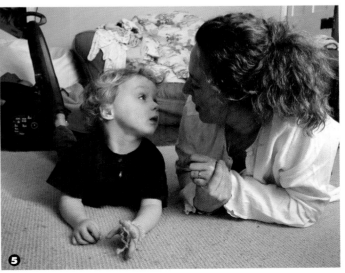

Working with Children

SPECIAL CONSIDERATIONS

When I was about five years old I was taken to a photographer's studio with my older brother for a sibling portrait. My brother was the perfect model. I, on the other hand, sensing that the photographer was a little nervous, showed him no mercy. I recall that very few pictures from that session were suitable for framing.

The fact is that, on the whole, children are more self-conscious about being photographed than adults, and their behavior in a photo session is apt to be more exaggerated, ranging from a display of extroverted bravado to a stubborn refusal to be photographed at all.

MAKING THEM FEEL COMFORTABLE

When kids are involved in an activity—a birthday party, for example—they are unaware of the presence of the camera. Candid family snapshots are often the best and most natural kind of photos, and the digital camera is ideally suited for this purpose.

In a more formal situation where children know they are being photographed it may take some effort and patience to make them feel relaxed enough to be good models. Try to make them part of the "team." Explain what you are doing— "I'm adjusting the exposure to bring out the colors in your sweater." Even if the child is too young to understand exactly what you mean, she will feel respected and will be more likely to overcome difficulties arising from self-consciousness.

PERMISSIONS AND CONSENT

When the models are not your own children, the parents' consent and permission is, of course, obligatory. In any case, have the parents sign model releases if the photos are to be used in any commercial way. It usually helps if at least one parent is present during the session.

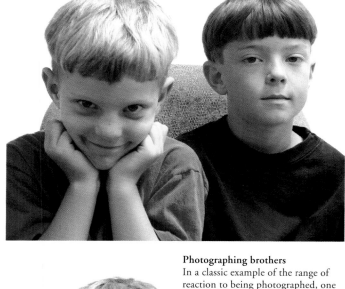

Photographing brothers
In a classic example of the range of reaction to being photographed, one brother remains aloof and enigmatic while the other proudly displays a gap-toothed grin.

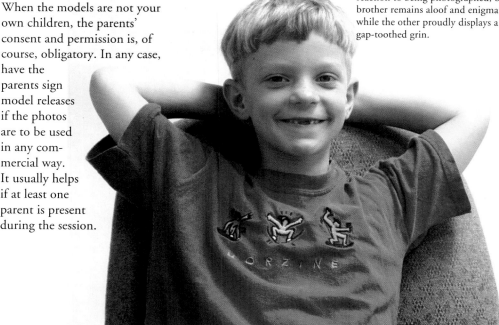

Photographing sisters
I used one incandescent light to the right of the models to warm up the flesh tones in an otherwise natural-light environment. The girls had very definite ideas about their poses, props and clothing. Fortunately, they were good ones.

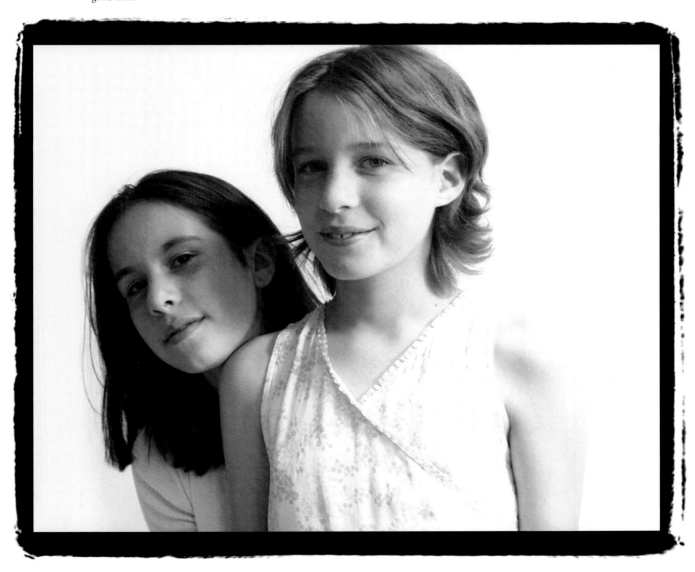

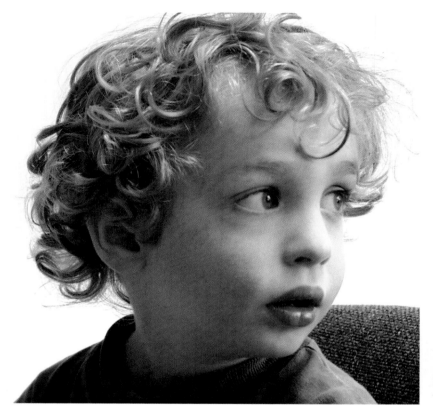

Involvement in choice

A child likes to see himself blown up large on a monitor. If you have a selection of pictures, ask him which one he likes best. (He'll usually pick a winner.)

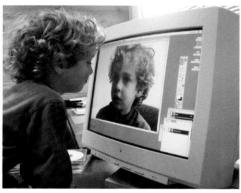

Involvement in the process

Showing the playback makes it possible for the child to understand exactly what is happening and helps him become more involved in the process. An involved child is more likely to be a patient and cooperative model.

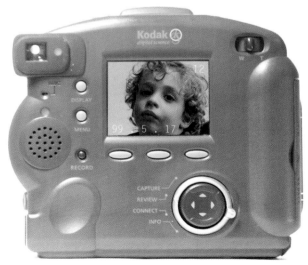

6 Working with Objects

Studio Setups

EQUIPMENT

A self-contained digital camera is a wonderful and versatile tool. But it has its limitations. Unlike the normal type of camera used in professional studio photography with a conventional film or a digital back, the self-contained digital camera has no manual focus or exposure controls, and its resolution is typically well below the level of a 35 mm film format, let alone many studio cameras that shoot 4" × 5" film and larger. With a camera that is not really designed for professional studio work, I believe it is rather pointless to invest in a lot of fancy studio equipment to support it.

Nevertheless, beautiful still-life and object images that are quite adequate for many purposes can be made with a digital camera, and the equipment requirements are modest and inexpensive.

TRIPOD

Besides the camera, the most essential piece of equipment is a tripod. A good tripod can be bought for around $50. It is absolutely essential to keep the camera still during indoor exposures because the light level is much lower than outdoors and the shutter speed that the camera will automatically select will be rather slow.

TABLETOP

Some kind of flat surface—a table, bench or countertop—is convenient to support objects that are not normally found standing on the floor. A normal height for a tabletop is 30".

LIGHTING

Lighting gives shape and form to the objects in the photograph. It defines the pattern of light and shade within the image area, creating harmonious composition and a sense of depth. The light direction, intensity and focus, and the relative lighting of the foreground and background are the variables that you can play with to create successful images.

In most cases natural light is sufficient to create excellent indoor object photography with a digital camera. If you are working in a windowless basement, or you prefer to work during the night, you will obviously need artificial light sources.

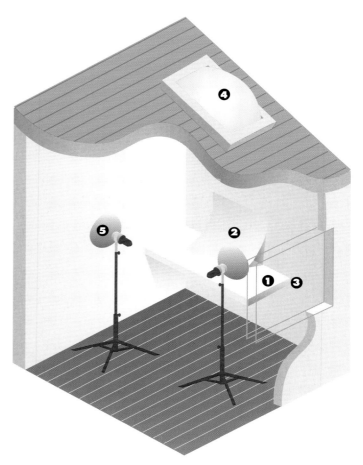

Setting up a small studio area
A small digital photography studio in the Northern hemisphere might include a countertop or table **1** and a background paper **2** for a working area, a north-facing window (south, if you live in the Southern hemisphere) **3** and a skylight **4** to provide optimal natural light, and incandescent floodlights **5** for auxiliary light.

Shooting down or across
Upright objects are photographed horizontally, at tabletop height or eye level. A sheet of paper, placed on the desktop and curving up to meet the wall behind provides a seamless background. Flat objects are best photographed from above. It is often necessary to lift flat objects slightly above the tabletop with shims to create shadows.

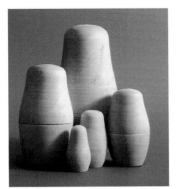

Diffuse lighting creates soft shadows. If a window faces north (south, if you live in the Southern hemisphere) there will never be direct sunlight falling upon your work area so your light source will be inherently diffuse. If your room has a skylight you will have the perfect natural light source.

In some cases you might need to augment natural light to gain control of the light direction and intensity. You can control the depth of field in your picture, for example, by constricting the camera's automatic pupil (smaller apertures increase the range of focus but require more light). In other cases you may want to create a tonal gradation in the background that is opposite to the objects in the foreground, adding definition to the shapes. For augmentation, floodlights with stands and reflectors can be purchased for about $100 for a set of two.

BACKGROUNDS

To provide a suitable background it might be necessary to dress up the stark tabletop with various background materials such as marble slabs, wood, metallic foil, plastic laminate or ceramic tiles. More often than not, however, a neutral background serving only as a means of providing shadows is all that is needed. A good general-purpose background can be made from a sheet of paper. Paper is inexpensive and recyclable and comes in many colors. Some papers have attractive textures. Fabric provides an even greater range of texture. For special effects, black velvet will produce a solid, shadowless black background, and white plexiglass, lit from behind or below, provides a shadowless white background.

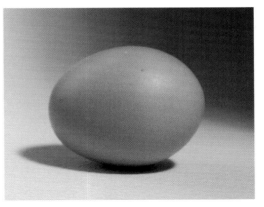

Controlling background and foreground tonal gradation
In an ideal lighting setup, the tonal gradation of the background should go in the opposite direction from the foreground. In this example, the egg is darker on the left side and the background is darker on the right side. This technique, borrowed from fine art, has the effect of separating the edge of the object from the background.

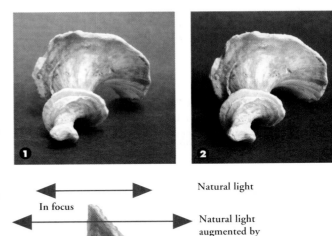

Natural light

In focus

Natural light augmented by floodlights

Controlling depth of field with lighting
The range of focus or depth of field in a photograph is determined by the width of the lens aperture. In natural light **1** only a narrow band in the center of the shell is in focus. When floodlights are added **2** the increased amount of light causes the automatic exposure system to select a smaller aperture, bringing most of the shell into focus.

Tabletop Still-life

Finding props
These colorful Mexican folk-art pieces create a ready-made composition. The green paper background sets off the reds and purples in the ceramic figurines.

GATHERING THE PROPS

Tabletop still-life photography is a way of creating images from groups of objects that are small enough to be assembled on a table. Objects are used in art photography to show the abstract qualities of lighting, color and composition. Designers use object photography either in a literal way to show merchandise, or in a symbolic way to communicate a message.

Thrift stores, garage sales, collectors and even your refrigerator are good sources of still-life material.

LIGHTING AND COMPOSITION

The same basic considerations of lighting that apply to portraiture apply also to still-life photography. In general, harsh lighting that causes dark, hard-edged shadows is as unflattering to objects as it is to people, and should be avoided. Diffuse light from windows, or indirect light bounced off walls or sheets of paper will create soft shadows and large, well-formed highlights.

Overlapping objects create a sense of depth and unify the composition. If typesetting is to appear within the image area, room must be left in the composition. The background should be either dark or light to contrast with the type and make it legible.

BACKGROUNDS

The object will stand out more if the background color is complementary to the object. An orange, for example, will stand out against a blue background. Very often you may want the background to fade out completely to white, or be represented by soft, light gray shadows so that the objects appear to float slightly above the printed page.

Arranging props
A boring subject, such as paying utility bills, can be made to look interesting. In this arrangement, the objects all overlap each other and are set at different angles. A comforting cup of tea completes the composition.

1

PRODUCT PHOTOGRAPHY

With a self-contained digital camera you can make product photographs for a wide range of media including fact sheets, promotional literature, printed or on-line catalogs. Products with lettering on them should be lit from the left side so that the beginnings of words are readable.

CLOTHING PHOTOGRAPHY

Clothing's lack of rigidity makes it difficult to photograph as a still-life subject. Treating garments as flat, two-dimensional objects often helps to solve this problem.

TOOLS AND EQUIPMENT PHOTOGRAPHY

The challenge with hardware photography is to overcome the monotony of the gray box. The highlights in metallic surfaces can be brought out by using reflector cards. Glass surfaces act as mirrors and can show unwanted reflections—including the photographer.

BOOKS, TAPES AND ALBUMS

These small rectangular items are easier to photograph shooting straight down, tilting the tripod slightly forward. Because in an advertisement or catalog layout the background will usually drop out, white-background covers may lose their edge.

Shooting product and concept shots
Sometimes a well-chosen prop, such as this cardboard puzzle **1**, can convey an abstract concept. Black velvet, draped behind, gives a solid black background, leaving room for type. Strong directional light generates harsh shadows, accentuating the layers in the model.

2 A mandocello (a guitar-sized mandolin) was placed on a sheet of white foam-core board and photographed from above at a distance of seven feet in a stairwell. The shiny purple of a cycling helmet is complemented by the surrounding yellow paper **3**. A light source aimed at the background, rather than the object, is causing a yellow glow on the object's edge.

❶

❷

FOOD AND DRINK

The photography found in magazines and recipe books makes food look so appealing, but you really wouldn't want to eat it if you knew what they did to it—using plastic "ice" cubes that won't melt under the hot lights, and motor oil on roast turkey to make it look more appetizing! With a digital camera and limited equipment you can still produce good food images without resorting to complicated techniques. A little water sprayed on fresh fruit wouldn't hurt. Beverages in glass containers usually look better against a black background. Bounce cards bring out the reflections in glass and chrome objects.

ORNAMENTS AND HOUSEHOLD OBJECTS

The many colorful and intriguing artifacts you may have collected will make wonderful subjects for still-life digital photography. Although these images may have little commercial value, they are a good exercise in exploring lighting and composition. Ordinary objects can sometimes be used symbolically. A close-up of an open

Shooting fruit
This bunch of vine-ripened tomatoes was photographed in natural light. A light spray of water adds interest to the surface and suggests freshness.

Shooting wine
A black velvet background brings out the highlights and reflections in glass. A single light source, to the left, is giving indirect light from a white bounce card. The smaller highlights are from windows and skylights. A spotlight from behind, aimed though a hole in the background might have produced the red glow in the wine glass, but the effect was actually achieved in Photoshop with a Hue/Saturation adjustment to a soft-edged selected area.

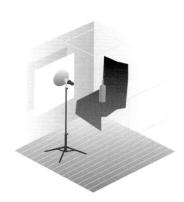

Prototyping an idea
This recipe card idea was photographed on a white sheet of paper placed on a tabletop with the camera aimed straight down.

RAW FOOD GOURMET

Alfalfa sprouts

Diced organic carrot

Nori

Pickled ginger

Diced avocado

SHOOTING FLAT ARTWORK THAT IS TOO BIG FOR FLATBED SCANNING

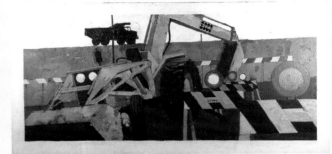

This acrylic painting measures 18" × 36". An original of this size would have to be scanned in overlapping sections, but a digital camera can capture originals of any size in one step. Two lights at equal distances on either side of the original serves as a good setup for making copy shots. The camera should be on the same level as the original and aimed directly at the target to avoid distortion.

Combining people and objects
An image of a small hand-held computer serves as a mock-up for a TV phone unit. The face, shot separately, was rotated and skewed to give it the right perspective to fit on the screen.

matchbox, for example, might be used for a cover of a brochure on anger management.

COMBINING PEOPLE AND PRODUCTS

The calendar on the wall of a car repair shop reminds us of how often commercial photography frivolously combines people and products in rather crass ways. But some objects make more sense shown in conjunction with a person or body part. For example, you might want to emphasize the scale of miniature hand-held electronic device by showing it in a person's hand.

Jewelry, footwear and other small clothing items can be shown to advantage with assistance from a model.

Working with Small Objects

SETTING THE CAMERA FOR CLOSE-UPS

Many digital cameras have a close-up or macro function that will allow you to take pictures of objects as close as 8" away from the lens. Small objects are brought into sharp focus, revealing details that are not apparent to the naked eye. Miniatures have an inherent quality that is both charming and graphic. Whether you have roses in your garden, or porcelain figurines on your shelf, you probably have many interesting subjects for close up digital photography within easy reach.

WORKING OUTDOORS

Architectural details and plants are some of the things worth considering for outdoor close-ups. Although a tripod is cumbersome outdoors, it helps keep the camera steady as you focus in at close range. Magnification of the image causes magnification of camera motion. Buildings tend to stay still, but plants, animals and people move. A leaf swaying in the breeze will blur the image.

IN THE STUDIO

A tripod is necessary to make crisp close-ups indoors. You can make a simple small-scale seamless backdrop from foam-core board and paper that will create beautiful soft shadows. If you want the background to drop away completely to white, use white paper and use spot metering on the object (see page 19).

LARGER THAN LIFE

The macro function makes it possible to reproduce objects larger than life-size, bringing out graphic details. All the imperfections of the original—toothmarks in a pencil, for example—will be apparent in the final image.

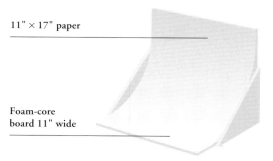

11" × 17" paper

Foam-core board 11" wide

Making a miniature seamless background
A handy support for small, lightweight objects can be made from pieces of foam-core board, glued together, and a replaceable sheet of paper. The assembly can be pinned to the wall or placed on an eye-level shelf.

Floral close-ups
Plants make ideal subjects for close-ups. The grasses were growing on the shores of a California lake. The fiery bloom is from my neighbor's garden. Both are hand-held exposures using the macro function.

How close is close enough?
Cameras may vary in close-up capability. A typical focusing range for a macro function of a digital camera is from 12 to 24". As long as the soccer player is between the red arrows he will be sharp; any closer or further away he will be blurred.

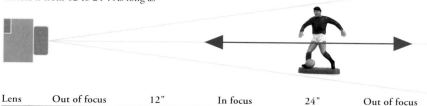

| Lens | Out of focus | 12" | In focus | 24" | Out of focus |

Larger than life
Small household items, toys, cake
decorations, twigs, shells and odds
and ends make wonderful subjects for
close-ups. These ten images are from
a series of shots using the macro
function of a digital camera.

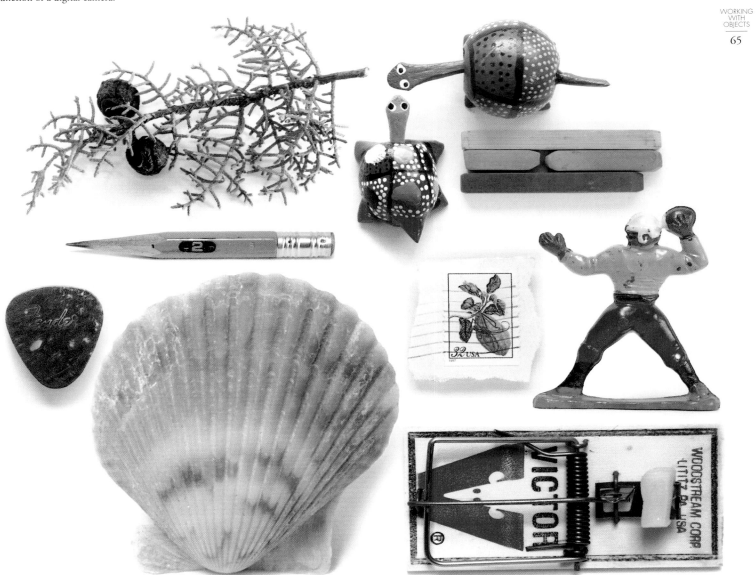

FOUND OBJECTS

Rather than gathering the props for your own tabletop, why not take the camera on location? Leaving the object arrangements and lighting conditions exactly as you find them and using only the camera to compose the layout, you can make good still-life compositions by adapting your methods to the situation.

Another quirk of reality worth capturing with the camera is the uncanny "presence" of inanimate objects. I like to photograph things that evoke human or animal attributes, or that represent some kind of visual "pun."

Objects with "presence"
3 A pile of rusting machinery resembles an animal or bird.
4 A fire hydrant stands at attention like a toy soldier.

Shooting still life on location
1 Artifacts from Mexico, Guatemala, and the American Southwest are crowded together in the rooms of a 1920s California bungalow.
2 The cluttered workbench of an instrument repairman forms an unintended still-life composition.

7 Editing Digital Photographs

Working with Tone and Color
Controlling Your Original Exposure
Improving Tonal Range
with Software
Color Correction

Enhancing Your Digital Photos
Getting the Picture
the Way You Wanted It
Digital Artifacts

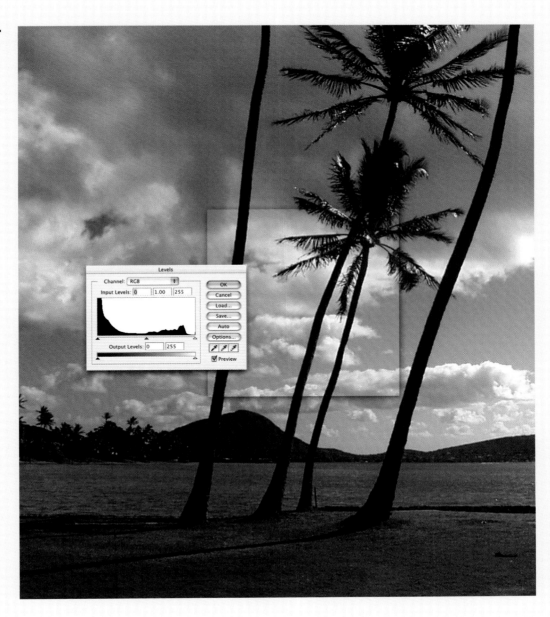

Working with Tone and Color

CONTROLLING YOUR ORIGINAL EXPOSURE

Most digital cameras perform well in making a good picture automatically. They are more tolerant than film cameras of fluctuations in light level and color temperature (the ambient light color). Nevertheless, a digital photographer with a computer will always be presented with both the temptation and the means to correct the image after it is recorded.

Although digital image-editing is relatively easy compared to darkroom work, it is also time-consuming. A correct original exposure saves time.

Unfortunately, many self-contained digital cameras offer only limited exposure control. This is particularly irksome to veteran photographers who are used to working with f-stops!

One approach to exposure control is to use spot metering (see page 19). Another way is to use exposure compensation settings to increase or decrease the automatic exposure. By "bracketing" the exposure in this way you are more likely to get the tonal balance that you want. Exposure bracketing is only really practical in a studio setting with portraiture or still-life work. On location there is usually no time to reshoot.

IMPROVING TONAL RANGE WITH SOFTWARE

In spite of all efforts to make a perfect exposure, some images may still need adjustment to their tonal range—the range of light and dark areas in the image. There may be exceptions—snowscapes, or dimly lit interiors—but an image should normally contain a full range of values between white and black. (However, special software used in preparing images for reproduction on a printing press may alter the end points of the range to prevent ink buildup.) The most widely used image-editing software is Photoshop, which was used for the examples on the following pages. The same results can be obtained with Photoshop Elements.

BRIGHTNESS AND CONTRAST

It's tempting to control the tonal range of a picture by using Photoshop's brightness and contrast controls, but they merely move the tonal range up or down, losing information at the extreme

+3

-1

+2

-2

+1

-3

Bracketing the exposure
With most self-contained digital cameras it is possible to modify the automatic exposure by fixed degrees plus and minus.

This sequence begins with an overexposure of +3 and ends with an underexposure of -3.

Digital ISO 1 = 100 ISO film (bright daylight)

Digital ISO 2 = 200 ISO film (outdoors overcast)

Digital ISO 3 = 400 ISO film (for low light)

ISO rates the *speed* of film—how fast it reacts to light. In some digital cameras the sensitivity of CCDs can be adjusted to approximate film speed settings.

ADJUSTING EXPOSURE ON THE FLY

Many compact digital cameras come equipped with large LED screens. This not only serves as an accurate viewfinder because the information is seen through the lens of the camera, but also as an information window for exposure adjustment. As you look at the image on the screen and press the button to increase or decrease the exposure or ISO you can see the results before taking a picture. The same compact digital camera used here is also capable of allowing the choice of aperture or shutter speed priority in Manual mode, thus giving many more of the features associated with traditional photography to the compact digital camera user.

Adjusting the exposure

Digital ISO 2 -2 stops

Second ISO 2 +2 stops

Original image with its Levels histogram

Black Gray White
Sliders

ends. In an effort to bring out detail in the shadows, for example, you may bleach away the highlights.

A better method is to use the histogram of the Levels controls or the gamma curve of the Curves controls.

USING A HISTOGRAM

When you access the Levels controls (Image > Adjustments > Levels in Photoshop, or Enhance > Brightness/Contrast > Levels in Photoshop Elements) a histogram, labeled Input Levels, is displayed next to the image. This histogram is a plot of the number of pixels at each lightness value. Beneath the histogram are three sliders that govern the black and white points and the midtones.

Original image

Auto Contrast—any difference?

Using Auto-adjustments
Photoshop and Photoshop Elements provide several automatic adjustment functions for tonal balance including Auto Contrast, Auto Levels and Auto Color. Quickly test and Undo to see how they affect your photograph.

If there are no apparent differences, chances are that your image won't need any actual adjustment for technical reasons.

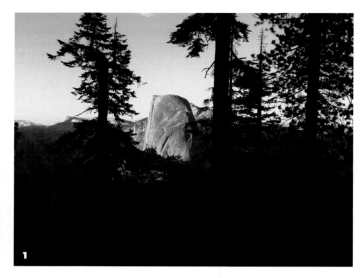

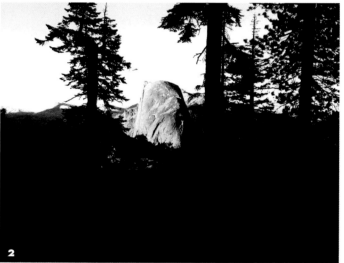

Setting black and white points with Auto Levels. The gaps in the histogram indicate that the image has been re-mapped.

Moving the input sliders inward increases contrast.

BLACK AND WHITE POINTS

Setting the values for the darkest and lightest areas is usually the first step in tonal range editing. In a given image, "black" and "white" might have values of 10 and 240 respectively, over a total of 256 possible brightness levels from 0 to 255. Resetting the black and white points to 0 and 255 will usually improve the tonal balance by spreading the brightness values over a broader range. You can do this automatically by clicking the Auto button in the Levels dialog box, or from the Image menu (Image > Adjustment > Auto Levels).

Adjustments to black and white points can also be made manually. Moving the black and white sliders inward on the Input

Re-mapping the tonal range
The histogram on the top shows the adjustment being made; the lower one shows the re-mapped histogram.
1 For this image Auto Levels produces an increase in contrast in the midtones without darkening the shadows or lightening the highlights.
2 Moving the Input sliders inward also increases contrast, but, since it's a manual setting, a more extreme change can be obtained.

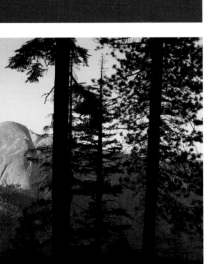

3

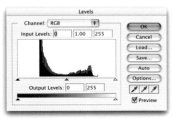

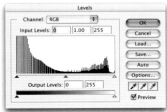

Moving the Output sliders inward
decreases contrast.

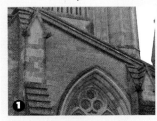

Moving the gray slider brings out
mid-range values.

Re-mapping the tonal range
3 Moving the Output sliders inward
decreases the contrast, creating an
overall haze. **4** Moving the Gray
slider left brings out detail in the
midtones and shadows, revealing a
fallen tree in the foreground.

IF IT AIN'T BROKE, DON'T FIX IT!

It's a mistake to assume that all
digital photographs need
adjustment to their tonal range.
More often than not, your camera
will get it right the first time.
Moreover, digital images can be
surprisingly fragile, and over-
adjusting them can introduce
unwanted noise **1** or abrupt tonal
transitions **2**.

Every image should be presumed
correct until proven otherwise. If
you're not sure, make a test print
of an unedited image and only
edit it if necessary.

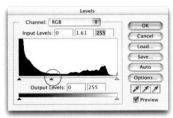

Levels scale re-maps those values to 0 and 255 on the output scale,
increasing the contrast. Conversely, moving the sliders inward on
the Output Levels scale reduces contrast by re-mapping the 0 and
255 levels inward (for example to 20 and 230), thus reducing the
tonal range of the image.

EDITING MID-RANGE VALUES

To brighten the midtones, move the gray slider left; to darken them,
move it right. These corrections will change the *gamma,* or midtone
contrast of the image.

USING A GAMMA CURVE

Gamma is a measure of the contrast in the midtones of an image. By adjusting gamma values you can cause a change in the contrast and brightness of the middle range of tones without noticeably affecting the darkest shadows or lightest highlights. Like the Gray slider in the Levels dialog box, the gamma is another way to fine-tune the tonal range of the image. Gamma curve editing is a function of Photoshop which is not available in Photoshop Elements.

Access to the gamma control is from the Curves dialog box (Image > Adjustment > Curves). The gamma is displayed as a line graph in which the brightness values of the "input" (the original digital photograph) are shown along the horizontal axis and the brightness values of the "output" (an edited version of the original) are shown along the vertical axis. When gamma is set at a value of 1, as it is before you make any changes to an image by manipulating the curve, all the input values are equal to the output values. When a photograph is in its initial state the gamma curve is a straight line at 45°, showing a one-to-one correlation between input and output values. When changes are made to the curve, the output values are skewed.

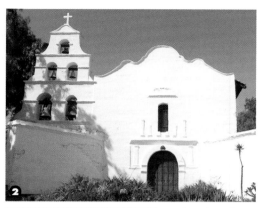

Using curves to correct for underexposure
1 The white expanse of the mission's wall caused the camera to underexpose the shadow areas and create an unnaturally dark blue sky.
The straight-line curve shows the initial state of the image. The histogram shows a preponderance of pixels at the dark end of the range.

2 Tweaking the curve redistributes some of the pixels toward the light end of the range, correcting the sky and the shadows without losing detail in the highlights of the white wall.

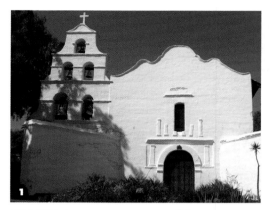

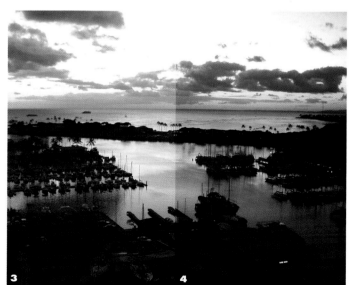

Using curves to correct for overexposure
3 This sunset photo suffers from the camera's light sensors overcompensating for the low light level, resulting in a loss of intensity in the sky. **4** Moving the curve toward the right deepens the midtones and brings the tonal balance toward a more realistic representation of the scene.

COLOR CORRECTION

You'll probably be quite pleased with the color accuracy of your digital camera and may find little need to make color corrections to your images. But there are always occasions when for one reason or another—perhaps a colored light source, weather conditions or time of day—you have a picture in which the color balance is not quite right.

GLOBAL COLOR CORRECTION

If your image is affected by an overall color cast, there are two recommended methods: Variations and Hue/Saturation. These two, like levels, Curves, and Color Balance, can be applied either to a section or to an entire image.

VARIATIONS

Perhaps the most intuitive method, Variations (Image > Adjustment > Variations in Photoshop; Enhance > Variations in Elements) gives you a visual matrix of "what-ifs." Simply select the variation that's closest to what you want, repeating the process if necessary. The Color Balance controls in Photoshop (Image > Adjust > Color Balance) do much the same thing.

HUE/SATURATION

Another useful control is Hue/Saturation (Image > Adjustment > Hue/Saturation in Photoshop; Enhance > Color > Hue/Saturation in Photoshop Elements), where you can adjust the *hue*, or color wavelength, and the *saturation*, the amount of gray in the color.

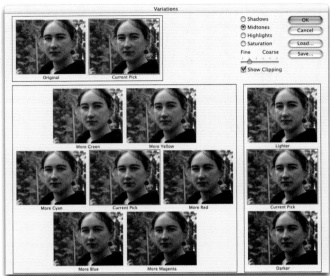

Correcting color with Variations controls
This backlit late-evening photo has an overall purple cast. To create more natural flesh tones, I clicked once on the Add Yellow image and once more on the Add Red image.

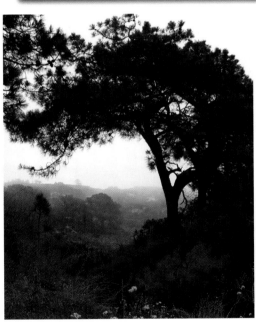
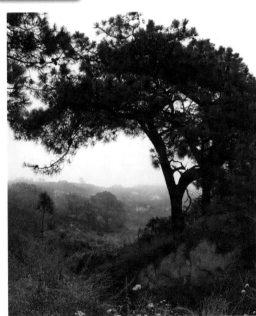

Correcting color with Hue/Saturation controls
My camera was unable to penetrate the gloom of the coastal fog to capture the richness of the colors in this canyon scene. I moved the Hue slider, tweaking it slightly toward the green. Likewise, increasing the Saturation and the Lightness values added more vividness to the greens of the foliage and to the bright colors of the wildflowers in the foreground.

SELECTIVE COLOR CORRECTION

Sometimes the need arises to change the color of a specific part of a picture without altering any other areas. You can easily change a person's eyes from brown to blue, for example, and not turn her face blue as well.

ISOLATED AREAS

It's often easiest to select parts of the image manually with one of the selection tools such as the Lasso or the Magic Wand. Then any of the tonal balance or color correction techniques described on the previous four pages can be applied to a selected area. But there are also some useful color-correction functions that make selections more-or-less automatic. Two useful ones are Replace Color and Selective Color.

REPLACE COLOR

When the Replace Color control is accessed (Image > Adjustment > Replace Color in Photoshop; Enhance > Color > Replace Color in Photoshop Elements), any part of the image can be selected with a Dropper tool. You can select either highlights, midtones or shadows, and you can broaden the range of the selection by increasing the Fuzziness. Alterations to the Hue, Saturation, and Lightness will apply only to the selected area.

SELECTIVE COLOR

Selective Color (Image > Adjustment> Selective Color in Photoshop only) controls the color balance within specific color ranges—Reds, Greens, Yellows, and so on—allowing very subtle editing.

Correcting color with Replace Color controls

Replace Color works well if you want to isolate a particular color for editing. Placing a Dropper tool—in this case, the highlight Dropper tool since the flower is considerably lighter than the background—on the petals designates the color area to be masked. The hue can then be altered in the flower, leaving the green background untouched.

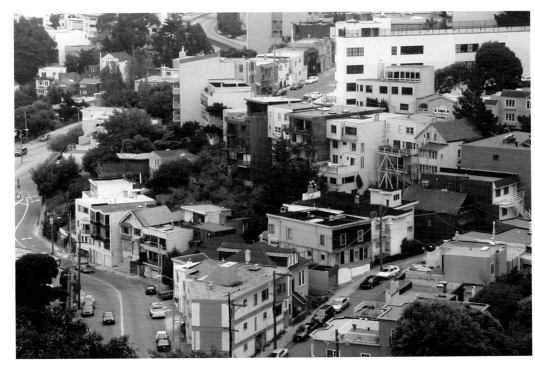

Correcting color with Selective Color controls
Selective Color gives you another way to edit specific color areas. I selected Reds and moved the Magenta slider to boost the magenta in the red areas, causing a richer tone in all the pink buildings without affecting any other parts of the picture.

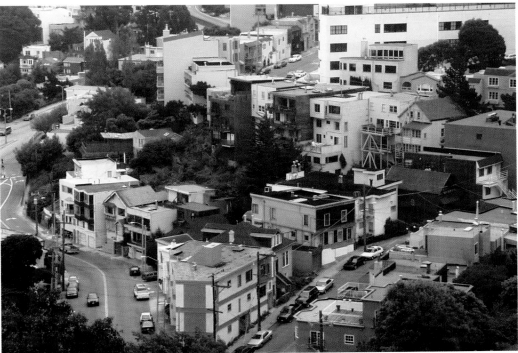

SEPARATING TONE
FROM COLOR

Usually, the greatest need for adjustment in digital photography occurs in the overall contrast and tonal range rather than in the color balance and saturation. So it makes sense to work on the tonal value separately from the color values.

One way to understand this process is to think of the black and white data as the "skeleton" of the photo, with the color adding flesh to bones. Correcting or enhancing color without careful calibration tools is risky and often unnecessary. A safer (and dramatically more effective) method is to work exclusively on the tonal range.

LAB COLOR

Using Photoshop's Lab Color mode (Image > Mode > Lab Color), you can isolate the tonal information from the color information and easily adjust the tonal balance as though you were working on a grayscale image.

The "L" in Lab Color refers to *luminance*, or brightness value. "a" and "b" represent the polar co-ordinates of a theoretical hue-saturation axis, also known as *chrominance*, or in Photoshop, Lightness.

Make adjustments to the "L" or Lightness channel. The "a" and "b" channels should be left intact. Production photographers use this method more than any other because it saves time and preserves the integrity of what the camera has captured.

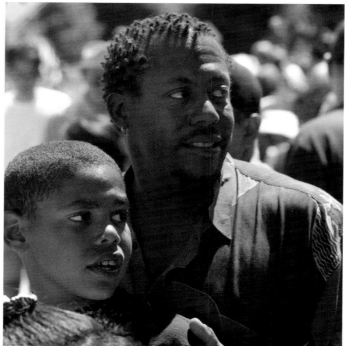

Original image

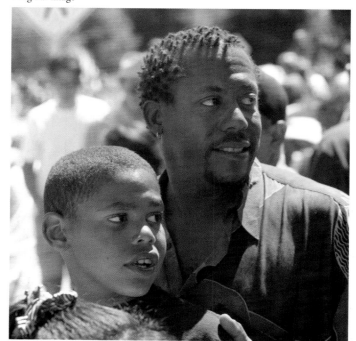

Corrected image. *Photo by Michael Price*

Using Lab Color to make tonal corrections

This photograph seemed flat in the shadow areas due to a slight underexposure. I first converted the RGB image to Lab Color, then applied a tonal correction to the Lightness channel with Levels. *Photo by Michael Price.*

Uncorrected Lightness channel

I moved the midtone slider to the left to lighten only the shadows without affecting the color saturation channels.

Corrected Lightness channel

Enhancing Your Digital Photos

GETTING THE PICTURE THE WAY YOU WANTED IT

Since *National Geographic* relocated some pyramids on its cover in the 1980s, the digital altering of images has become commonplace. Image altering is nothing new. In pre-computer days, it was unusual for any advertising photography to go to the printer without considerable retouching with the airbrush.

ELIMINATING EXTRANEOUS DETAILS

From fixing minor blemishes to removing the supporting structures from object photos, your digital photos will almost always be improved by leaving things out.

CHANGING THE COMPOSITION

Sometimes it is necessary to change the composition either for aesthetic reasons or to fit a predetermined layout. Common methods include cropping, changing the framing from horizontal to vertical (and vice versa), tilting the image, and extending backgrounds. Some of these techniques are shown on the following page.

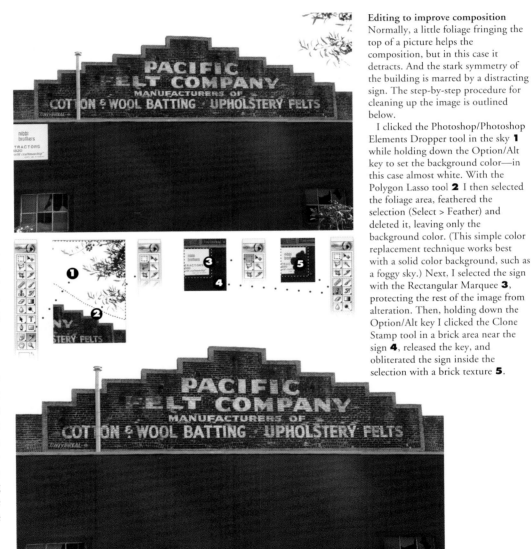

Editing to improve composition
Normally, a little foliage fringing the top of a picture helps the composition, but in this case it detracts. And the stark symmetry of the building is marred by a distracting sign. The step-by-step procedure for cleaning up the image is outlined below.

I clicked the Photoshop/Photoshop Elements Dropper tool in the sky **1** while holding down the Option/Alt key to set the background color—in this case almost white. With the Polygon Lasso tool **2** I then selected the foliage area, feathered the selection (Select > Feather) and deleted it, leaving only the background color. (This simple color replacement technique works best with a solid color background, such as a foggy sky.) Next, I selected the sign with the Rectangular Marquee **3**, protecting the rest of the image from alteration. Then, holding down the Option/Alt key I clicked the Clone Stamp tool in a brick area near the sign **4**, released the key, and obliterated the sign inside the selection with a brick texture **5**.

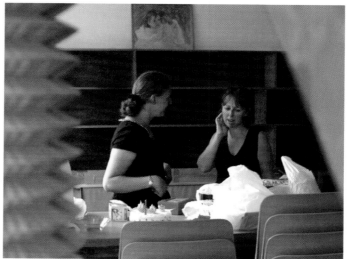

Changing a vertical into a horizontal
Sometimes an image has a strong central subject, yet suffers from poor framing, crooked horizon, or extraneous visual clutter.

This shot was leaning right and needed 2 degrees of rotation correction. Then, the vertical framing, which didn't show the relationship between the two subjects, was improved by cropping out the lower third and upper quarter. I retained the picture above the heads and removed most of the other items on the shelves behind them with the Clone Stamp tool.

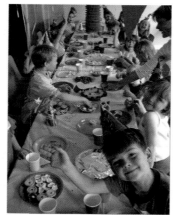

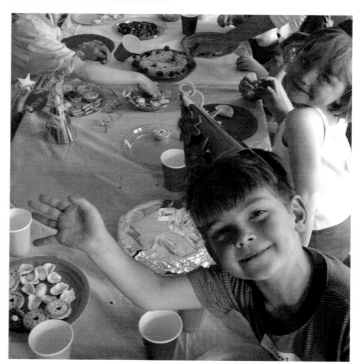

Cropping to improve composition
One of the blooms looks slightly off color and out of place, and the grey path detracts. The cropped image allows the eye to focus on the red blooms, without suggesting there was anything more to the shot from which it was cropped.

Re-framing from vertical to square and editing unwanted items
In this image none of the kids are waving or looking at the camera, except the two in the foreground. To make the most of this I re-scaled the portion of the image containing the interested kids, cropping the rest of the image away.

Being able to enlarge items successfully without pixelation relies on a reasonable amount of output pixels—4.8 megapixels in this case, giving ample room for maneuver. It's often best to shoot at maximum resolution because you can always decrease the resolution in your editing package, but you can't increase the pixels without image distortion.

Although the enlarged crop looked reasonable, it also required extraneous item removal. Again, using the Clone Stamp tool in Photoshop/Photoshop Elements, I confiscated the plate of cheese-puffs by the boy's outstretched hand and the green cup behind the crest of his party hat. *Photos by Tim Odam.*

REMOVING BACKGROUNDS

Eliminating backgrounds, or *sil-houetting*, is a widely used technique in graphics which turns your image into an iconic shape.

When removing backgrounds in Photoshop or Photoshop Elements the key is the tonal relationship between the subject and its background. Is it lighter, darker, or the same tone? Are some parts of the background lighter than the foreground and others darker? Is the edge of the foreground object angular, curved or amorphous? Consideration of these factors will determine the best method. This page and the following page show examples appropriate for various typical situations.

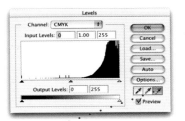

Removing a light background, but retaining the shadows

First I used a highlight Dropper icon (Image > Adjustment > Levels in Photoshop, or Enhance > Brightness/Contrast > Levels in Photoshop Elements), which turns most of the background white without substantially affecting the shadows. Then I used the lasso to select around the image, staying beyond the shadows. Finally, I inverted the selection and feathered it 5 pixels before deleting the background.

Removing a background that is close in tone to the foreground

I used the Pen tool to outline the engine pod because of its smooth curves. The Pen tool creates a path which can be turned into a selection, and the selected area can then be deleted (or filled with a color).

Another way to use the Pen tool to eliminate a background is to create a clipping path.

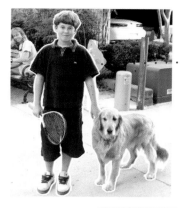
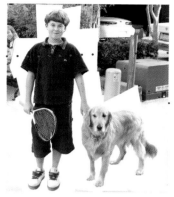
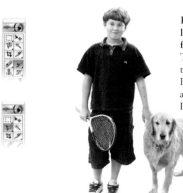

Removing a background that is both lighter and darker than the foreground: hand method
This requires patience. I started with the Photoshop/Photoshop Elements Paintbrush tool using white "paint" and finished with the Lasso Polygon tool.

Removing a uniform background that is different in tone than the foreground
The Photoshop/Elements Magic Wand tool automatically selects areas of similar color. I experimented with the tolerance settings and held down the Shift key while clicking to select the entire sky.

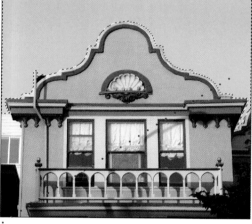

Once selected, the sky can either be filled with white or deleted.

Removing a background that is both lighter and darker than the foreground: semiautomatic method
The Photoshop/Elements Magnetic Lasso tool actively seeks edges. I held down the Shift key to add the space between the tree branches to the selection.
The way in which this clever tool hews to the edge of shapes is impressive; the results are not always altogether satisfactory.

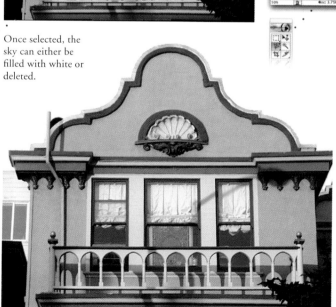

SILHOUETTING WITH THE EXTRACTION FILTER

Like a Swiss Army knife crammed with useful gadgets, Photoshop provides yet another tool for silhouetting images—the Extraction Filter from the Filter menu. (Photoshop Elements does not come with an Extraction Filter.)

Dragging a Highlighter tool defines the image boundaries, leaving a semi-transparent fluorescent trail much like a real-world highlighter. Next, clicking inside the closed highlighted area with the Paint Bucket completes the selection of the area to be extracted. As might be expected, this method works better with some images than with others. The extraction process sometimes produces a curiously artistic edge effect.

Highlighting the edge

Filling the center

The extracted image

DIGITAL ARTIFACTS

A digital artifact is something that appears in the image which originated in the capturing process, rather than in the real world. In digital photographs, artifacts tend to be most noticeable in detail areas of high contrast, such as foliage against a sky background. There are two primary causes: photosite spillover during capture (see page 9) and compression while the image is being stored.

IMAGE COMPRESSION

Digital cameras use various forms of compression when recording images, expediting data transfer and allowing more exposures to be stored on the memory media. On a typical camera, a compression factor of 10:1 may allow 24 images to be recorded while a factor of 4:1 might allow only 8.

However, compression is *lossy*, causing degradation of the image (see page 157). Some of the artifacts of compression are a halation around contrasty edges, stair-stepping, and blocky shapes within areas of even tone.

USING SOFTWARE FILTERS

The Smart Blur filter in Photoshop/Photoshop Elements can overcome many of these flaws, although it cannot eliminate them altogether. Perhaps the best mitigation is simple reduction. When an image is reproduced at a reduced size, compression and spillover artifacts are far less noticeable.

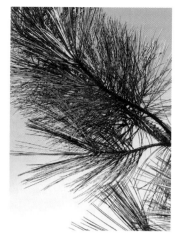

Flatbed scan of a conventional color print
The inset area has been filtered to exaggerate digital artifacts.

Uncorrected digital photograph
The inset area reveals the typical blocky digital artifacts.

Digital photograph after Smart Blur filtering
The digital artifacts have been suppressed.

8　Transforming Digital Photographs

Manipulating Images

GRAYSCALE FROM COLOR

Most digital cameras make beautiful color pictures whether you want them or not—unless your camera happens to have a black-and-white setting. To make a black-and-white photo, the color photo has to be converted in Elements or Photoshop.

The simplest way to make a black-and-white image is to desaturate it (Image > Adjust > Desaturate.) This method creates a monochrome image in which the Red, Green, and Blue channels are identical. It is still technically a color image, however, and when converted to

Converting color to monochrome
1 The original color image has a good distribution of highlights, shadows, and midtones. Desaturation removes color from the image **2**, but it remains a color file. Printing the image in four ink colors increases the tonal richness. Converting to grayscale **3** discards all color information. The image is printed in black ink only. The separate color channels of the original picture, Red **4**, Green **5**, and Blue **6** show different tonalities. The blue sky is dark in the red channel, for example, but light in the blue. The different channels give options in making the conversion to grayscale. (Further adjustments to the tonal range of a grayscale image can be made using the techniques described on pages 69–72.)

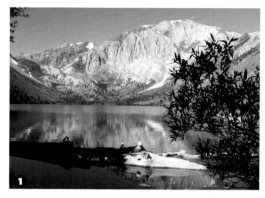

Creating a duotone

When a grayscale image is assigned an overall ink color **1**, the tonal range is limited so that the picture looks flat. On the other hand, a duotone conversion **2** splits the image into two channels—one for each ink color. Editing the gamma curves for each ink gives you control of the amount of each ink color in the midtones, highlights, and shadows.

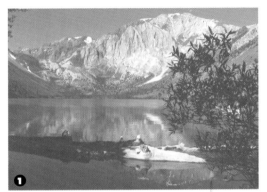

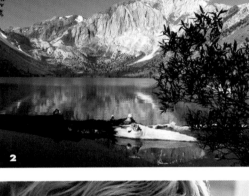

CMYK for offset printing, it will reproduce in all four inks.

If you are reproducing your picture in monochrome, a grayscale conversion (Image > Mode > Grayscale) is appropriate. Although black-and-white laser printers automatically convert color images, making your own grayscale conversions saves file space and gives you more control.

Another way to produce grayscale images from color files is to examine each color channel in turn. Then copy the one whose tonal range is best for monochrome into a new file, or combine two channels.

DUOTONES

In a duotone, two ink colors are used to print an image. Typically, a duotone contains black and a spot ink color. Photoshop provides a method for creating duotones from grayscale images.

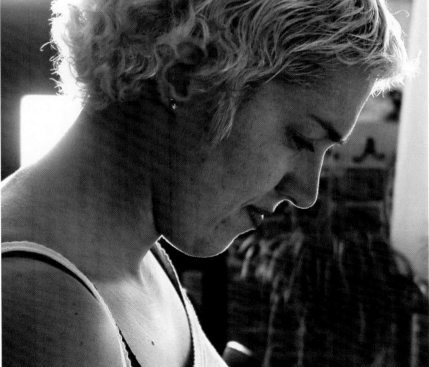

Adding warmth to a portrait

Duotones make attractive alternatives to color images and are especially effective in portraiture. Since duotones are based on a commercial ink color model they must be converted back to RGB for inkjet printing.

Making a subtle change
Since this beach photograph is almost monochromatic, switching the Red and Blue channels by copying and pasting in the Elements/Photoshop Channels palette makes only a slight difference, giving a subtle brown cast to the sky.

ARTIFICIAL COLOR

A color image recorded by a digital camera consists of three channels that correspond to the primary light colors: Red, Green, and Blue. This is known as an RGB image. When the image is prepared for printing, it consists of four channels that correspond to the primary pigment colors: Cyan, Magenta, Yellow, and Black, referred to as a CMYK image.

By manipulating and transposing the various channels, you can change the color range of a digital photo in interesting ways varying from subtle to hallucinatory.

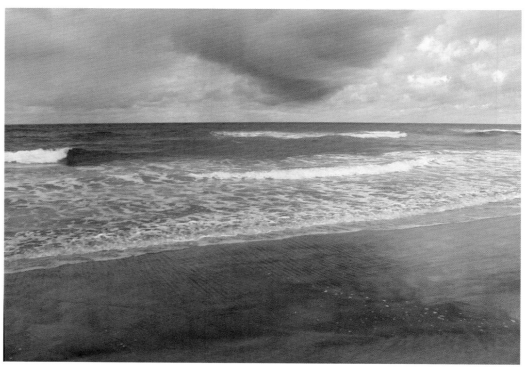

Using gamma curves to produce solarized colors
Radical manipulation of the curves can create bizarre color transformations.

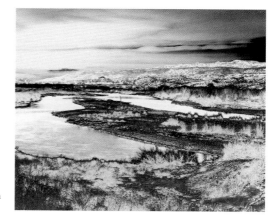

Creating artificial color in RGB
This image was transformed by switching the Blue and
Green channels in Elements/Photoshop. To achieve this, I
first copied the Blue channel to a new empty channel, then
I selected the Green channel and copied it to the Blue
channel. Finally, I copied the new channel (the original
Blue) into the Green channel. Although the colors of most
of the fruits are radically altered, the flesh tones and the
oranges remain unchanged.

Creating artificial color in CMYK
In this Photoshop CMYK image the
Cyan and Magenta have traded
places, leaving the Yellow and black
unchanged. It is almost as if someone
had turned the sign upside-down and
changed the season to winter.

MEZZOTINTS

A *mezzotint* is a traditional graphic arts special screen effect that breaks up the image into a random pattern of dots, reminiscent of an old lithograph. Normally applied to black-and-white photographs, mezzotints can also be in color. To apply a mezzotint effect to a digital photograph you can use the Elements/Photoshop Mezzotint filter (Filter > Pixelate > Mezzotint), but the effect is rather coarse and I do not recommend it.

A better (but more laborious) way of making a good color mezzotint involves changing each of the separate color channels from grayscale to bitmap (Image > Mode > Bitmap), and applying Diffusion Dithering. First make a copy of each color channel as a grayscale file, convert the image files to bitmap, then replace each of the original color channels with the dithered image.

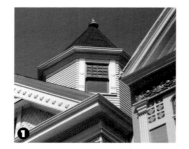

Using dithering to create a color mezzotint effect
Elements/Photoshop's Mezzotint filter is somewhat unsatisfactory: It merely adds "noise" to the image **1**. To make a more pleasing mezzotint, copy each of the Red, Green, and Blue channels in turn to a new file and convert them to Bitmap mode, using Diffusion Dithering **2**. When these dithered images are pasted back into each channel, the result is a finer mezzotint **3**.

Printing text over a mezzotint
Mezzotints from dithered bitmap images make good backgrounds where typesetting overprints. For the sake of legibility, the photo should be printed in a light color.

TEXTURES

Adding an overall texture, such as canvas or paper, to a photograph is easily accomplished in Elements/Photoshop. A texture filter lightens and darkens portions of the image to create an illusion of a surface below the picture, and can simulate the effect of a print on canvas, stone, wood, or some other material.

Adding an overall texture to digital photographs

1 The brick texture from Elements/Photoshop's Texturizer (Filter > Texture > Texturizer) applied to a digital photo of clouds resembles a mural. Burlap from the same filter **2**, and Sandstone **3**, suggest weaving and lithography.

Combining an Artistic filter with a Texture filter

4 A dramatic sea-cliff photograph is given the Elements/Photoshop Palette Knife treatment **5** (Filter > Artistic > Palette Knife). Now an overall background texture of Canvas was added with the Texturizer **6**. The end result has the look and feel of an oil painting. (For more about Texture filters see pages 95–99.)

HIGH CONTRAST

High-contrast transformation emphasizes the graphic qualities of a photograph. Best results come from images that are fairly contrasty in the first place, and which contain good detail.

START WITH
A DIGITAL
CAMERA

90

MAKING A BLACK-AND-WHITE IMAGE

For a high-contrast effect, first convert to grayscale. The image can then be converted to black-and-white by maximizing the Contrast setting and adjusting the Brightness (Image > Adjust > Brightness/Contrast).

MAKING A BITMAP IMAGE

A *bitmap* (Image > Mode > Bitmap) produces binary image files containing pixels that are either present (white) or completely absent (black).

OVERLAYING BLACK-AND-WHITE AND COLOR IMAGES

With access to each channel in RGB or CMYK modes, other high-contrast transformations are possible, including retaining the color information in the

Making a color graphic from a black-and-white photo
1 A black-and-white digital photo of wooden water towers is converted to a high-contrast bitmap **2**, then converted to RGB where a bold color design was made by filling the white areas with color **3**.

Placing a high-contrast bitmap image over a color area
The high-contrast bitmap image of a waterfront city skyline has been printed in gray over a blue panel. The white areas of the bitmap are transparent, allowing the color to show through.

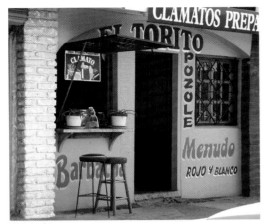
Original image

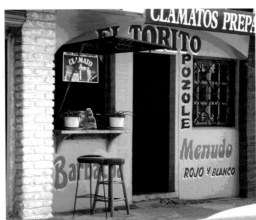
8 levels

Applying posterization
Elements/Photoshop's Posterize function simplifies the color palette of an image. For example, selecting four levels (four gray levels for each color channel) assigns all the pixels to one of twelve possible generalized colors.

A shot of a Mexican café is posterized at 8, 4, and 2 levels.

Cyan, Magenta, and Yellow while reducing the Black channel to a bitmap image, or superimposing a bitmap copy of the image on the original RGB file.

POSTERIZATION

Posterization reduces an image to two or more colors or graytones. In Photoshop you can use Image > Adjust > Posterize. This technique simplifies tonal information into a few levels of flat color, reminiscent of the silk-screened poster. The number of levels can be specified: the lower the number, the more radical the transformation of the image.

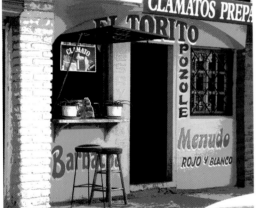
4 levels

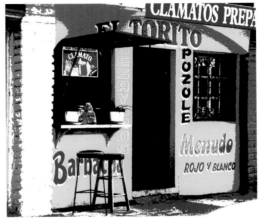
2 levels

Grayscale posterization
Posterization can be even more effective in black and white than in color. An 8-step posterization of a backlit subject brings out the texture of the shirt, the brick wall, the stucco, and the skin of the neck while placing the face in mysterious shadow.

Applying high-contrast black over color
One variation of the high-contrast technique is to boost the contrast in the black channel of a Photoshop CMYK file, leaving the other colors unchanged.

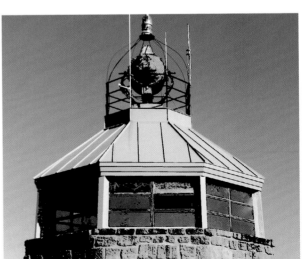

Simplifying by Gaussian Blur
Applying an overall Gaussian Blur to this picture removed most of the detail **1**. Maximizing the contrast and adjusting the brightness **2** created a very graphic abstraction **3** suitable for a logo or sign. The same technique used on a photo of a hotel building **4**, and forest wildflowers **5**, makes dramatic designs.

START WITH
A DIGITAL
CAMERA

92

BLURRING

You can take a sharply delineated photograph into a level of abstraction by blurring it. The simplified patterns of color and tone can reveal the elegant underlying shapes that form the image.

GAUSSIAN BLUR

Elements/Photoshop's Gaussian Blur filter (Filter > Blur > Gaussian Blur) allows you to control the amount of blurring. Increasing the contrast further simplifies the image.

MEDIAN FILTER

The Median filter (Filter > Noise > Median) spreads the colors into each other as though the picture were melting—an effect somewhat similar to a watercolor.

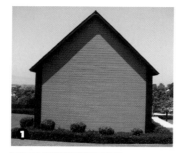

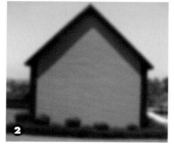

Simplifying with the Median filter
Applying the Median filter to an image causes the tonal areas to bleed into each other like wet paint.

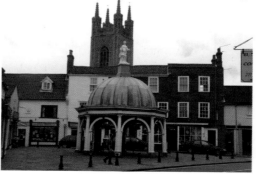

Flare
A lens flare adds drama to a backlit industrial roofline.

DYNAMIC EFFECTS

Certain effects can give an image a feeling of action and drama—life in the fast lane, or in the spotlight. A few of the many dynamic effects that can be applied to digital photos are shown on this page.

LENS FLARES

You might get an unintended lens flare by shooting into a light source, however, Elements/ Photoshop's Lens Flare filter (Filter > Render > Lens Flare) gives you an aesthetically pleasing one.

DIRECTIONAL BLURS

A blur may be given directionality to convey motion (Filter > Blur > Motion Blur). The effect can be set to any angle and distance. A zoom effect can be made with a Radial Blur (Filter > Blur > Radial Blur).

WIND

Similar in appearance to a motion blur, the Wind filter (Filter > Stylize > Wind) produces streaks that resemble the conventional speed lines of commercial art.

Motion
A motion blur is an easy way to convey speed. It affects the entire image or a selected area. In this case I deselected and feathered part of a wheel to anchor part of the image before applying the blur effect.

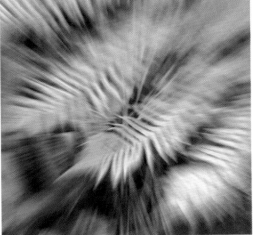

Wind
The Wind filter produces stylized motion streaks at the edge of shapes, while leaving most of the image intact.

Zoom
A radial blur increases motion from a focal point, suggesting a zoom.

LINEAR TRANSFORMATIONS

Photos can be warped in various ways for graphic effect. This is one place where the geometry you learned in school actually comes in handy. Some of the simpler and most useful transformations are straightforward linear geometric distortions. These transformations include scaling, skewing, perspective, and distortion. Remember that before making a transformation the entire image (Edit > Select All) must first be selected, or a portion of it must be selected with a selection marquee.

START WITH
A DIGITAL
CAMERA

94

SCALING

Scaling enlarges or reduces images by stretching or squeezing horizontally or vertically. In Photoshop, choose Edit > Transform > Scale, and in Photoshop Elements choose Image > Resize > Scale. To scale proportionally in Elements/Photoshop, hold down the Shift key.

SKEWING

Skewing distorts a rectangular image into a parallelogram. In Photoshop choose Edit > Transform > Skew. In Photoshop Elements choose Image > Transform > Skew.

PERSPECTIVE

Perspective distorts a rectangular image into a trapezoid, with two sides parallel and two sides convergent. In Photoshop choose Edit > Transform > Perspective. In Photoshop Elements choose Image > Transform > Perspective.

DISTORTION

Distortion allows any handle to be dragged independently, distorting the image into an irregular polygon. In Photoshop choose Edit > Transform > Distort. In Photoshop Elements choose Image > Transform > Distort.

OTHER TRANSFORMATIONS

In addition to its transformation tools, Elements/Photoshop's many other transformations can be found under the Filters menu (Filters > Distort). Among these filters are Shear, Wave, Ripple, Pinch, and Polar.

Shearing
Photoshop's Shear filter (Filter > Distort > Shear) bends the image into an arc. In this example the image has been rotated 90° after shearing.

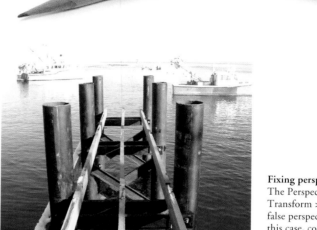

Fixing perspective
The Perspective tool (Layer > Transform > Perspective) can add a false perspective to a picture, or, as in this case, correct for distortion by making all the vertical lines parallel.

Using Special Effects and Filters

Filters have played a role in photography for over a century. Filters on cameras and enlargers normally govern the color of light reaching the image. Some more specialized ones might produce soft or stellated highlights, but there is nothing in the compass of conventional photography comparable with the hundreds of virtual filters that can be applied with digital image-editing.

On the next five pages are some of the graphic filters that come with Photoshop/Elements. Some of the graphic filters for color images are grouped under Artistic, Pixelate, Stylize, and Texture in the Filter menu.

Graphic filters are analogous to adding reverb, echo, and chorus to audio—techniques that can be very effective if done tastefully but annoying when overused.

Some Pixelate filters

Color Halftone

Crystallize

Facet

Pointillize

Mezzotint (long strokes)

Some Artistic filters

Colored Pencil

Colored Pencil

Dry Brush

Underpainting

Fresco

Paint Daubs

Palette Knife

Plastic Wrap

Poster Edges

Rough Pastels

Watercolor

Smudge Stick

Sponge

Some Texture filters

Craquelure

Some Stylize filters

Tiles

Texturizer: Burlap

Patchwork

Stained Glass

Find Edges

Original image

Standard application of Palette
Knife filter settings

Maximum application of Palette
Knife filter settings

Standard application of Palette
Knife filter to low resolution file

SIZE MATTERS

Most Elements/Photoshop filters come with settings that govern the strength of various filter parameters. Since filters rearrange pixels, the fewer pixels there are to be acted on, the more the image will be affected by the filter. Adjusting the filter settings allows the user to match the strength of the filter effect to the size of the file.

However, applying the maximum filter effect to a large image file is not quite the same as applying a minimum filter effect to a small image file. Moreover, if a file is extremely large—six megapixels or more—the filter effect may be negligible.

It's worth experimenting with reducing the size of the image *before* using a filter to see if the effect is more pleasing than at normal size.

Some Brush Strokes filters

Accented Edges

Angled Strokes

Dark Strokes

Ink Outlines

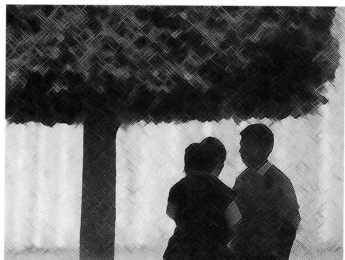

Crosshatch

Sprayed Strokes

Sumi-e

Some Sketch filters

Chalk and Charcoal

Charcoal

Graphic Pen

Stamp

Torn Edges

Conté Crayon

Notepaper

Photocopy

Chrome

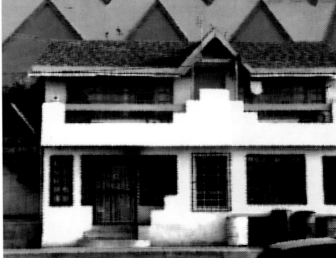

Water Paper

Creating Montages

A montage is a composition of multiple images, often at different scales, that form an abstract composition, unlike a panorama in which multiple photographs are pieced together to form one continuous picture (see pages 28-29). The use of the term *montage* in graphic design and illustration has come to mean a juxtaposition of various visual elements, arising from the Cubist tradition in which different view angles of a subject are presented simultaneously, fragmented and overlapped in unusual ways.

Photoshop and Photoshop Elements enable a sophisticated approach to montages by taking advantage of discrete layers. These layers may be combined as overlapping opaque areas, transparent overlays, or some combination of the two.

OPAQUE

A simple montage of opaque elements often makes a satisfying design. Using a grid, the elements can be layered in a structured way that harmonizes and balances the composition. Sometimes the angular effect of opaque montages can be eased by "feathering" edges of the images so that one part of the picture blends into another, and various selection techniques can be used to isolate shapes within a photograph (see page 79). By repositioning and scaling the images, and by shuffling the order of the layers, different compositions can be obtained.

TRANSPARENT

In the transparent approach to montage, an accumulation of layers gives rich and subtle textures. Controlling the degree of transparency of each layer emphasizes particular shapes and colors or creates new ones in areas of overlap. When too many layers are used, a montage can become dark, dense, and lacking in contrast.

Varying layers in scale, rotation, and transparency
In this multiple image of old cars and signs, some layers have been rotated slightly. Others have been reduced to give a contrast in scale. Some layers are semi-transparent, and some edges have been selected, feathered, and deleted. (A similar technique is used to make panoramas, see page 28.)

Using a grid to make a montage
1 An impressionistic composition of a seaport is built up from several opaque, overlapping layers. Portions of the images on each layer have been selected and deleted along the lines of the grid.

Photoshop/Elements layers may be given different properties, affecting the layers below. By setting some of the layers to "Lighten" so that darker areas below show through, a more richly textured blending occurs **2**.

The "Overlay" layer property setting, which affects areas below that are both lighter and darker than the top layer, adds a further degree of abstraction **3**. Some of the lower layers are set to "Normal," otherwise they would disappear completely.

ADDING EDGE EFFECTS

A rough edge on a photograph is associated with a handmade print, going back to the time of daguerreotypes and glass plates.

Special filters that create an irregular edge on photographs make the task of generating an antique effect much easier than hand-finishing (ironically), and offer a large number of different edge styles.

On this page are some examples of the hundreds of edge effects from Auto F/X (autofx.com), a Photoshop plug-in, applied to digital photos.

Edge effects can be applied to the inner edge of the image (Inset), or the outer edge (Outset), or both. Adding a border or margin to the image by increasing the Canvas size will create yet another style.

Auto F/X PhotoGraphic Edges No. 283. A black border was first added to the photograph.

Auto F/X PhotoGraphic Edges No. 252 with yellow margin

Auto F/X PhotoGraphic Edges No. 39 (outset) and No. 136 (inset)

Auto F/X PhotoGraphic Edges No. 298

Auto F/X PhotoGraphic Edges No. 297. A black border was first added.

Auto F/X PhotoGraphic Edges No. 158

Combining Digital Photography with Other Graphics

MIXING SCANNED LINE ART

For traditional paste-up methods, all kinds of royalty-free images are available from books—known as "clip art" because of the scissors-and-glue method of removing the artwork from the book. Although the term is still in use, you don't have to mutilate books anymore. You can either use a desktop scanner to capture royalty-free artwork, or use a digital camera to copy it (see page 63).

Some designers feel that using other artists' work shows a lack of originality; others look on it as a form of creative recycling. However, the combination of different elements, some original, some borrowed, creates a new entity which is in itself original.

MIXING HAND-DRAWN ART

If you are handy with brush, pen, or pastel, all kinds of creative possibilities present themselves. For example, a pencil sketch traced from a digital photographic print can be superimposed onto the original image to make an interesting illustration.

1

Combining graphic and photographic
This book cover is an example of the layering of photographic images on top of a scan of a map.

2

Mixing metaphors
1 An engraving of a sun symbol superimposed on images of the four traditional elements (earth, water, air, and fire) forms the cover of a booklet on renewable energy. **2** A combination of scanned line art and digital photographs illustrates the concept of the fable of the blind men and the elephant.

Combining the graphic with the photographic
From an extensive collection of line art symbols *(Design Elements by Ultimate Symbol)* I selected these whirls. In Photoshop I pasted digital images of flowers and foliage into the black areas of the shapes.

COMBINING TYPOGRAPHY WITH PHOTOS

Combining type with images transforms photography into graphic design. Almost every piece of printed material that we see every day—magazine covers, book covers, posters, billboards and so on, consists of a combination of typesetting and photography. How well these two communication modes are integrated determines the success of the design.

Typography can be used as a foreground or background element. Letterforms can be used in an entirely abstract way as part of a composition, where they blend in with the photography, or they can stand out in the foreground to proclaim a message that is supported by the photograph.

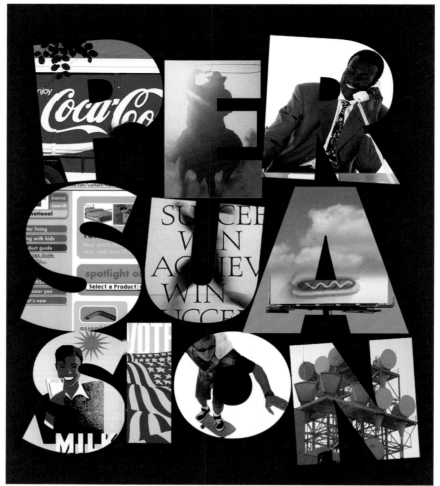

The medium is the message
Photographs and graphics projected onto lettering make an editorial point about various modern methods of publicity.

9 Creating Textures and Backgrounds

Textures and Backgrounds from Nature

TEXTURE IMAGES

The grass in a field, the sand on a beach, the clouds in the sky: all these are often included in a photograph but might be considered too dull to be its subject. Surprisingly, these background elements often make impressive images in their own right. The abstract quality of the grain in wood or the swirls in a rock can be brought out by filling the image area with nothing but the material itself.

Allowing your viewfinder to focus on only pattern, color and texture, and excluding all other considerations can be an amazingly liberating creative process. This concentration on the purely abstract can hone your skills in composition, layout, and color awareness.

In graphic design, patterns and background images from nature are popular and useful. You can purchase excellent natural backgrounds as part of the many royalty-free collections now available on CD, but you may not always find exactly what you need. The digital camera is an excellent tool for extending the range of background images available from stock photography with unique, high-quality images that are crafted to suit any specific purpose.

Successful texture and background images are generally flat and lack depth. They should contain less contrast and tonal variation than other photographs. Their purpose is to provide an overall background for type or other graphic elements. In their end uses, textures are often tactile and subliminal, evoking a mood or feeling.

ENVIRONMENTAL TEXTURES

Almost any natural environment can be the source of a texture image. Some of the more useful ones are:

 Clouds and skies
 Earth and sand
 Water
 Wood
 Plants and foliage

Typical texture and background images that are easy to take with a digital camera appear on the next eleven pages, together with examples of how they might be used in various kinds of graphics.

Evening sky

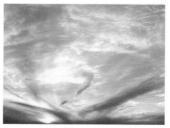

A winter sunset

Approaching storm

Cloud textures

Soft-edged features, such as clouds, will often baffle the digital camera's automatic focusing system, preventing the picture from being taken. If this happens, first focus on the horizon, then aim the camera at the sky.

HOW DO YOU FOCUS ON CLOUDS?

Clouds are nebulous by definition and thereby tricky to capture with an automatic focus camera. The cameras's auto-focus sensor detects contrast, but clouds very often lack contrast, and the focus function does not operate properly. Some cameras have an infinity setting which will work perfectly, but if you have no way of overriding the automatic focus, first point the camera at the horizon, or a well-defined distant object. Hold the shutter button down, but don't shoot yet. Now aim at the sky and click. Your cloud picture will be in focus.

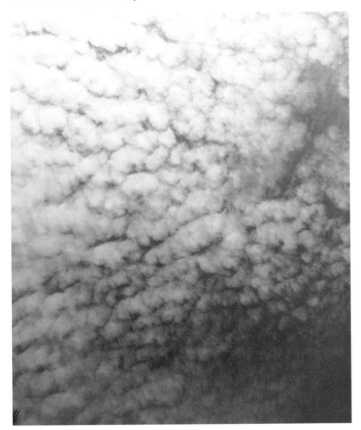

High altitude clouds

Desert clouds

Hazy clouds

Rain is expected

An angry sunset after a storm

Rosy sunset

Earth textures
Monochromatic textures from the
earth include sand, gravel, and mud.

Clay

Sandstone bluff

Excavation

Sandbar

Gravel

Sandy bank

Tidal sand

Cobbles

Dry mud

Mudflat

Wet mud

Tidepool

Dealing with Grief

COMING TO
TERMS WITH
SEPARATION,
LOSS &
BEREAVEMENT

Water textures

Essentially colorless and translucent, water depends on its reflective properties, its surface undulations, and the surrounding environment to give it form.

Waterfall

Fountain

River

Mountain stream

Surfline

Swimming pool

Polluted drainage

Riverbank

Seashore

Reflecting pool

Ocean sunset

Rock textures
Subtle and subdued in color, rock textures convey permanence and solidity.

Sand on sandstone

Sandstone

Lichen on granite

Shale

Granite

Red sandstone

Marble

Moss on limestone

Gravel

Blue lias

Rubble

Shingle

Wood textures

In its many forms, wood offers a great variety of textures.

Shingles

Weathered plywood

Weathered planking

Tabletop

Carved sign

Bark

Cedar tongue-and-groove

Chipboard

Bark

Fencing

Foliage textures
Colorful foliage make good overall
backgrounds with low tonal variation.

START WITH
A DIGITAL
CAMERA

112

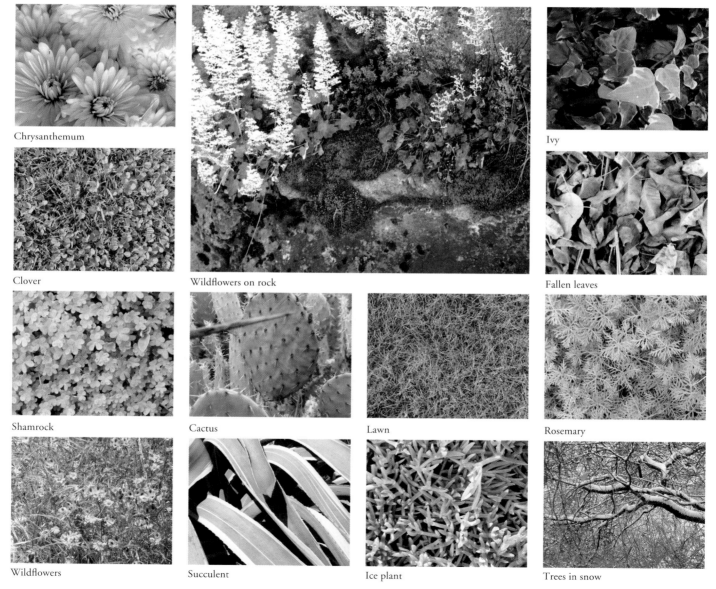

Chrysanthemum

Ivy

Clover

Wildflowers on rock

Fallen leaves

Shamrock

Cactus

Lawn

Rosemary

Wildflowers

Succulent

Ice plant

Trees in snow

Textures from the Human Environment

Textures from building materials
Brick, stone, and concrete are the characteristic textures of an urban environment.

URBAN TEXTURES

Street-level textures range from the grimy, graffiti-encrusted walls of an urban building to the polished chrome of a downtown office. The patterns and textures created by human hands and machines tend to be either more geometric than natural textures—brick walls, for example—or more chaotic, as in the frenzied splatter of paint on concrete.

Observation with abstract qualities in mind reveals intricate textures, dynamic patterns, and occasional bold colors contrasting with the ubiquitous grays. With peeling paint and rust, nature often reclaims the abandoned human artifact with interesting results.

Textures from the urban environment include:
Brick and tile
Concrete
Old paint
Graffiti
Construction paraphernalia
Debris

Brick pavers

Floor tiles

Concrete

Brick wall

Stone wall

Exposed aggregate

Chicken wire

Retaining wall

Stucco

Construction signs

Textures and patterns from signs and peeling paint
The bold geometric patterns of construction signs and the subtle patina of old paint and rust make excellent backgrounds and textures.

Rusty valve

Painted pipe

Construction markers

Barricades

Painted wall

Dumpster

Architectural detail

Sheet metal wall

Decorative fence

Painted valve

Debris textures
Building sites and junkyards abound with interesting monochromatic textures.

Painted surface textures
Paint applied to concrete, wood, and brick, or painted on glass, provides colorful textures and patterns.

Hand-painted sign

Steel pipes

Utility markings

Sand bags

Peeling paint

Mural

Road markings

Steel bars

Weathered sign

Painted steps

Step marking

Screws

Store window

Graffiti

Urban wall

HOUSEHOLD TEXTURES

Everyday materials that you might find in the home can make good background images for digital photography. Because many of these items are small and flat, they can also be placed in a desktop scanner to make backgrounds, but more natural-looking images arise from the digital camera. Some ideas for household texture props might include:

Fabric
Paper
Candy
Shells
Tarpaulin
Fossils
Packing materials
Cake decorations
Coins
Metal foil
Paper clips
Pins
Polished stones

Fabric textures
The geometric patterns and textures of woven fabrics and the intricacy of colorful prints make excellent backgrounds for type.

Canvas

Taffeta

Canvas

Denim

Floral print

Plaid

Sailcloth

Gingham

Houndstooth

Herringbone

Towelling

Canvas

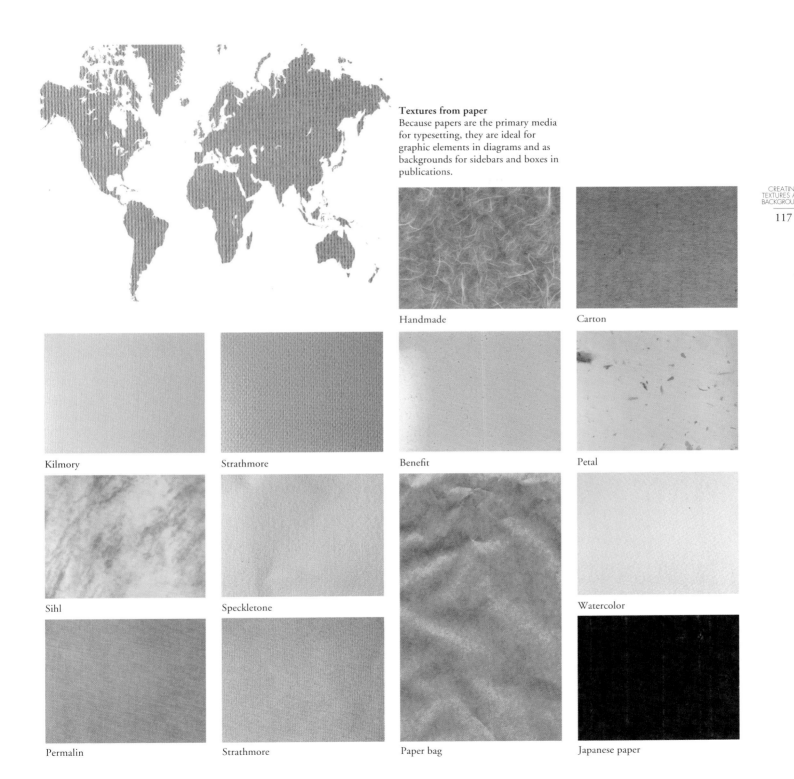

Textures from paper
Because papers are the primary media for typesetting, they are ideal for graphic elements in diagrams and as backgrounds for sidebars and boxes in publications.

Handmade

Carton

Kilmory

Strathmore

Benefit

Petal

Sihl

Speckletone

Watercolor

Permalin

Strathmore

Paper bag

Japanese paper

Textures from household objects
Textures are found in many
household objects— things we might
collect and things we might throw
away.

Candy

Sea shells

Tarpaulin

Fossils

Packing material

Cake decorations

Coins

Metal foil

Paper clips

Map pins

Polished stones

Mirrored ball

Foam

Styrofoam cups

Guitar case

Modifying and Extending Textures

USING ELEMENTS AND PHOTOSHOP TO MODIFY TEXTURES

Sometimes a design or layout requires a texture with a completely abstract quality—like a painting by Jackson Pollock. You may discover that many of the texture images you have captured with your digital camera are already only a short step away from complete abstraction.

If you have an image-editing program, such as Photoshop, it's worthwhile to experiment with filters and functions. (See pages 95–99.) Some of the more useful transformations include combining several textures in layers; overlapping two copies of a texture at different angles; distorting the image with Ripple, Wave, or Swirl; using the Artistic filters that imitate painterly techniques; and using Mosaic, Facet, or Glass functions to break up the surface of the texture.

Repeated applications of the Elements/Photoshop Swirl filter over selected areas of a floral print fabric simulates traditional bookbinding.

Several images of spray paint textures combined in layers with the Difference blending mode creates an abstract texture.

Using the Glass filter on a picture of a glass building creates an attractive background in which the original subject is no longer recognizable.

The Elements/Photoshop filter Colored Pencil was used to transform this digital photograph of a painted steel mesh structure into a cloth-like texture.

Overlapping a rotated copy of these steel pipes created a strong abstract design. The rotated copy was overlapped in Lighten mode.

The Ocean Ripple filter applied to a photo of architectural glass breaks up the image to a sparkling texture.

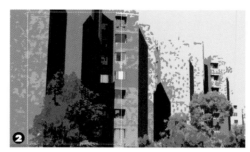

REPEATING PATTERNS

Textures and patterns derived from digital photographs can be extended over large areas by repetition. A brick wall texture, for example, can be mapped onto a three-dimensional computer model of an entire building. How the edges of these images match up when repeated must be considered if the aim is to create the illusion of a continuous texture area.

Almost any image can be a starting point for a repeating graphic. Look for interesting patterns and shapes captured from the real world by the camera. Vector outlines of shapes within digital images can be made either by hand-tracing or by using auto-tracing programs, such as Adobe Streamline. These shapes can also form the basis of repeating patterns and textures.

Making a graphic repeating pattern
An ordinary digital photograph of an apartment complex **1** is simplified by applying the Elements/Photoshop Cutout filter (Filters > Artistic > Cutout) **2**. A portion of the image, when cropped and repeated with a stagger **3**, creates a bold abstract design.

MAKING A SEAMLESS TILE

For a pattern to repeat without obvious seams, the edges of the image must be modified to make a smooth transition. **1** First find an image with a consistent overall texture. **2** Next use the Elements/ Photoshop Offset filter (Filter > Other > Offset) to move the image diagonally and "wrap" the edge pixels. **3** Now use the Clone Stamp tool with a large-diameter soft-edged brush to camouflage the hard seams. To ensure a seamless tile effect, repeat steps 2 and 3

Seamless editing
If the seam-disguising is done carefully, it should be impossible to detect the edges of the repeating pattern.

Repeating pattern
Overall patterns of vegetation, like these kimberly ferns, make successful repeating patterns.

CREATING ABSTRACT DESIGNS

A digital photograph can be the starting point for an intriguing and completely abstract design. Overlapping symmetrical rotation produces different kinds of mandalas; blurring and posterization further abstract the image to make background graphics for presentations, video titles, and web pages.

Making a concrete mandala
A copy of the image was rotated 180° and superimposed on the original image with the Darken mode selected. This composite image was then copied again, superimposed and rotated 90°, and put in Lighten mode.

Making a glass vortex
This dynamic pattern was created by using the special KPT Vortex filter.

Making a flip-flop pattern
Three duplicates of a picture flopped horizontally and vertically make a bold geometric design.

10 Direct Digital Output

Working with Desktop Printers
Black-and-White Laser Printers
Color Laser Printers
Inkjet Printers

Creative Ways of Using Digital Prints
Creating Cards, Envelopes, and Gift Wrapping

Quality Digital Prints
Printing on Fabric and Art Papers
Digital Output to Photographic Paper

INKJET PRINTERS

Introduced in the 1980s as a low-cost alternative to the laser printer, inkjet printers have remained popular because they produce color images. Although the printers themselves are quite cheap, ink and paper are not. A year's supply of ink and paper may exceed the cost of the printer!

Low speed is the principal drawback of an inkjet printer. Whereas a laser printer coats an electrostatically charged drum with toner, then transfers the image quickly to the paper, an inkjet printer builds the image line by line by aiming microscopic bursts of ink directly at the paper. This meticulous printing method rules out the inkjet printer as a means of high-quantity reproduction.

What inkjet printers lack in speed is gained in quality. Their reproduction of digital photographs is superb. In fact, it can

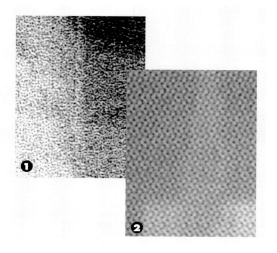

be difficult to tell the difference between an inkjet print of a digital photo and a high-quality photographic print. They are also capable of printing onto many different media, such as textured paper and fabric.

MAKING PRINTS WITH INK

Inkjet printers deliver ink to paper in various ways. The pattern of ink distribution can be either *stochastic*, like a Pointilliste painting by Seurat, for example, or *rasterised*, like the mosaic of dots on a TV screen. (See "Inkjet Printers: Two Different Methods of Reproduction" on this page.) Depending on the type of inkjet printer, ink is propelled either by a burst of heat or by

the vibration of a piezoelectric element. The tiny nozzles that deliver the ink to the paper are arrayed in clusters on the print head assembly. The quantity of ink emitted is controlled by the printer's image processor and by the driver software. The driver software determines which nozzles are fired, and when. By making two passes, the print heads can produce an image of very high resolution.

You should avoid getting fingerprints on the paper when feeding it into the printer because skin oil will repel the ink. Prints should also be handled with care because the ink smudges easily.

RESOLUTION REQUIREMENTS

The resolution requirements for inkjet printers are somewhat lower than for laser printers. A good inkjet print can be made from a digital photograph at resolutions as low as 144 pixels per inch.

PAPER TYPE

The type and quality of the paper significantly affects the appearance of the print and color accuracy. Matte papers give more natural highlights and glossy papers give brighter colors and richer blacks. For best results, use paper made by your printer manufacturer, and be careful to select the correct paper type in your printer driver.

INKJET PRINTERS:
TWO DIFFERENT METHODS OF REPRODUCTION

Different types of inkjet printers use either dot distribution or dot density to create images.

1 An enlargement of output from the Epson inkjet printer reveals a random pattern of very small cyan, magenta, yellow, and black dots like the grain in photographic film. Variations in color are caused by the proximity of the dots to each other. In dark areas the dots are clustered close together and in lighter areas they are more sparse. A certain amount of color mixing occurs when the dots overlap.

2 An enlargement of output from the Iris inkjet printer shows a pattern of equal-sized dots in cyan, magenta, yellow, and black that resemble the phosphorescent dots on a color TV monitor. Variations in color are caused by the variations in the amount of ink applied in the dots.

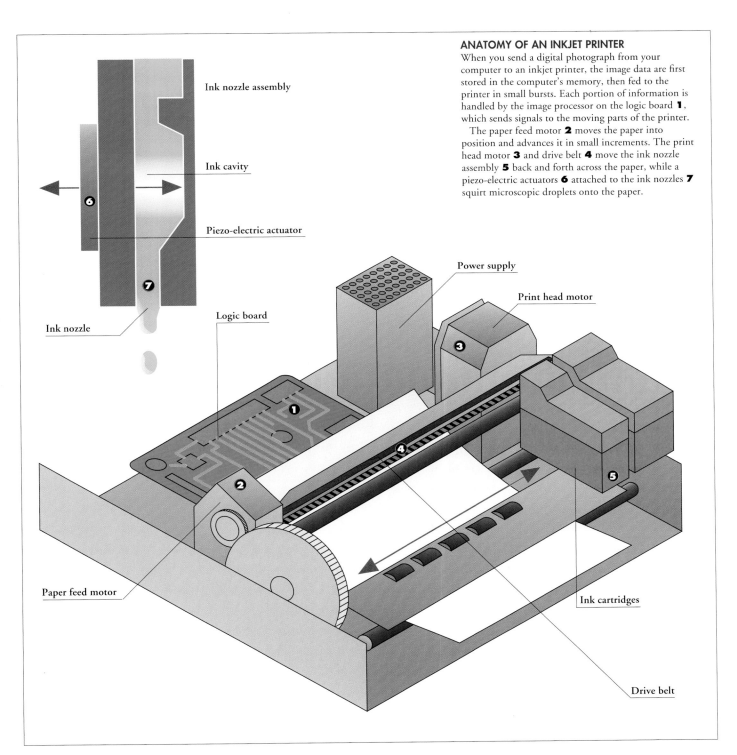

Ink nozzle assembly

Ink cavity

6

Piezo-electric actuator

7

Ink nozzle

ANATOMY OF AN INKJET PRINTER

When you send a digital photograph from your computer to an inkjet printer, the image data are first stored in the computer's memory, then fed to the printer in small bursts. Each portion of information is handled by the image processor on the logic board **1**, which sends signals to the moving parts of the printer.

The paper feed motor **2** moves the paper into position and advances it in small increments. The print head motor **3** and drive belt **4** move the ink nozzle assembly **5** back and forth across the paper, while a piezo-electric actuators **6** attached to the ink nozzles **7** squirt microscopic droplets onto the paper.

Power supply

Print head motor

3

Logic board

1

4

2

5

Paper feed motor

Ink cartridges

Drive belt

BIG INK OUTPUT

The industrial counterpart to the desktop inkjet printer is fed by rolls of special paper up to 3 feet wide. These large inkjet printers are used to produce huge graphic panels for display purposes at exhibitions where the viewer will be a few feet from the image. The typical large-format printer shown on these pages is affectionately known as "Big Ink" and operates at the Bath (UK) facility of Interface Ltd.

This printer uses water-based, rather than pigment-based inks, so the ink can take some time to dry on the media—especially if there are deep tones in the image. Since water-based inks remain on the surface of the media, lamination or framing is recommended to prevent smearing.

1 Big Ink uses eight ink colors: light cyan, light magenta, medium magenta, medium cyan, full tone cyan, magenta, yellow, and black. The medium and light inks have been introduced (as in many smaller inkjet photo printers) to help with tonal differences in the most and least saturated areas of an image, and to reduce *banding*—visible incremental steps in tonal transitions.

2 A Raster Image Processor, or RIP, a dedicated computer terminal, takes the digital photographs from a disk provided by the client and prepares them for printing **3**. The normal resolution requirement is 200 pixels per inch, but we were able to print these images at only 133.3 pixels per inch by using a special routine to compensate for lack of resolution **4**. With this technology, prints as low as 72 pixels per inch are quite acceptable for graphic (if not photographic) display. At these lower resolutions, the printer "dithers" the pixels that would be affected, producing a slightly blurred image.

After output comes mounting and lamination to preserve and strengthen the images. Laminate (gloss laminate used here) comes in gloss, matte, and pearl finishes. First, glue sheets are applied to 3 mm foamboard cut to size. The glue sheets offer a strong and bubble-free bond between the board and the image. **5** Next, the image is placed over the board, the backing sheet of the glue removed and passed through heated pressurized rollers to create a firm bond. The laminate is applied to the top of the image in the same way. **6** The boards are then trimmed to get rid of any excess edge material.

Finally, Velcro strips are fixed to the back of the boards for easy placement on exhibition panels **7**.

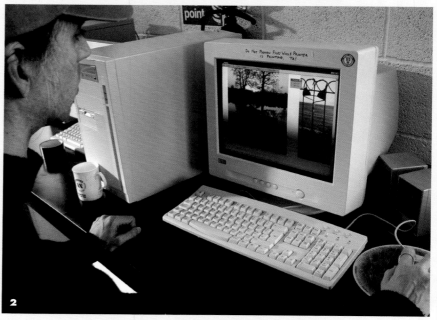

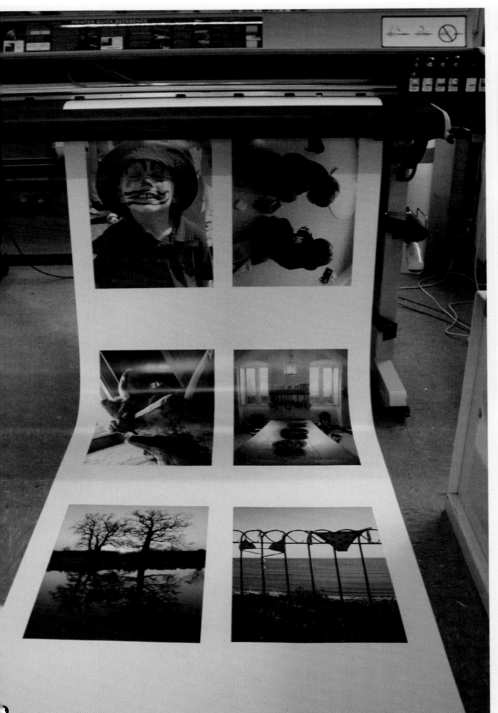

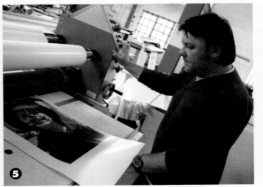

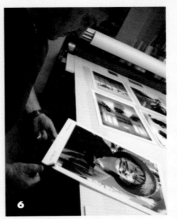

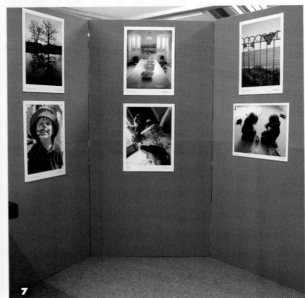

Creative Ways of Using Digital Prints

CREATING CARDS, ENVELOPES, AND GIFT WRAPPING

Inkjet prints of digital photos with a little typesetting make attractive cards. Family pictures and photos from trips and vacations are an obvious choice, but you can also select favorite things and details from your environment. Prints can be folded and placed in envelopes, or images can be paired up and cut in two to make postcards.

Digital photos of patterns and textures (see Chapter 9) make wonderful gift wraps and envelopes. With a color printer that can print on various kinds of paper you can use your digital camera in combination with your printer as a starting point for personalized gift items. I recommend thin paper because it's easy to fold.

Many digital cameras will not produce images that are big enough to cover a full 8½" × 11" sheet of paper without enlargement. If you have scruples about printing digital images when they are enlarged, you might consider using the seamless tile technique described on page 121.

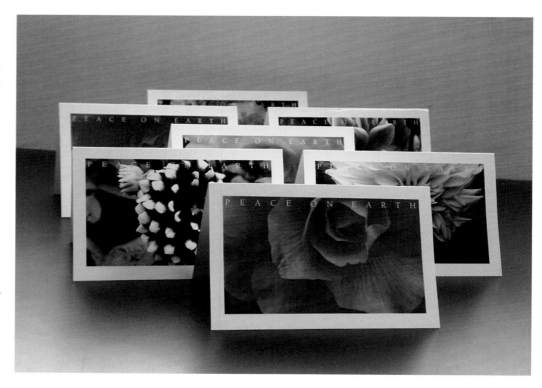

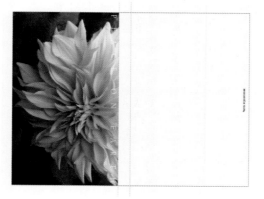

Making greeting cards
A trip to your local botanical gardens with a digital camera can yield a fine crop of greeting cards. These cards are printed on 8½" × 11" sheets of paper, folded to 5½" × 8½". The layout is a simple 1-page document with ½" margins all round, with one digital photo cropped to 7½" × 4½" positioned at one end of the sheet.

Making a gift wrap

1 One-of-a-kind wrapping paper, derived from digital photos, can be printed on an inkjet printer. This wrapping is for small gifts only—a sheet of paper will wrap nothing bigger than a CD.

2 To do a neat wrapping job, the object being wrapped may need to be placed at an angle and the paper folded and sealed carefully on the back.

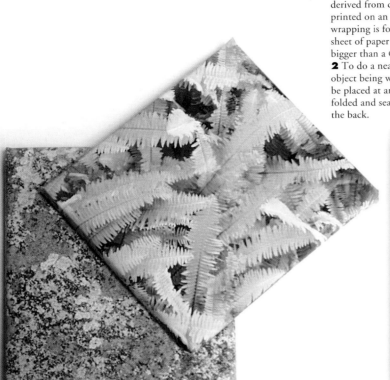

❶

❷

Making a small envelope

3 You can set up a template like this in a drawing program that will print color TIFF files.

4 Then cut and fold the print.

5 Use a glue stick on the flaps to make a unique envelope with a digital photographic lining.

❸

❹

❺

CREATING "MINI-BOOKS"

A digital camera and a color inkjet printer can be used in combination to make small-scale photography books.

Based on the very simple idea that books are made from large sheets of paper printed, folded, trimmed, and bound, you can feed a sheet of paper into your printer, turn it around, print the other side, fold it twice, trim off the folded edge and the excess margins, sew up the spine with thread, and there's your booklet.

First, choose your images (a narrative of a city tour or a stroll on the beach, for example). You might want to make a preliminary layout using a layout program that you can print from (see "Making a layout" on this page). The final matrix of pages that is put together so that everything comes out in the right sequence and right side up is known as an *imposition*. Copy the images one by one to a two-page imposition document, rotating the images for pages 3, 4, 5 and 6 (see "Making an imposition" on this page).

Here are some tips:

• Running a picture across two pages can be complicated unless done at the middle two pages of the booklet.

• Use coated paper. Plain paper is too absorbent and lacks opacity. Colors will bleed through to the other side of the sheet.

• Be sure to use paper that is coated on both sides. (Most types of inkjet paper are coated on only one side.)

• When sewing the spine, make five equally spaced pilot holes with the needle before sewing.

Books in miniature
Mini-books can be either vertical or horizontal. By using two sheets of paper you can make a 16-page book. After folding the pages carefully and trimming the top edge with a razor blade or art knife, sew the spine with needle and thread.

Making a layout
Using PageMaker, InDesign, QuarkXPress, or a similar layout program, make an eight page template at 4¼" × 5½"—smaller if your images will bleed off the page. Place digital photos on separate pages in sequence.

Making an imposition
Create a new two-page file at 8½" × 11". Divide each page into four and note the page number and rotation of each division according to the imposition chart below. Cut and paste the images from the eight-page template file one by one, and place them into their respective quadrants, rotating as necessary.

Producing a spiral bound booklet

Folding and sewing works fine for mini-books up to 12 pages, but for longer books, spiral binding produces a neater result. Most office supply stores or duplicators offer a spiral binding service.

The pages of this mini-book were printed on glossy inkjet paper and glued back to back with spray-on adhesive.

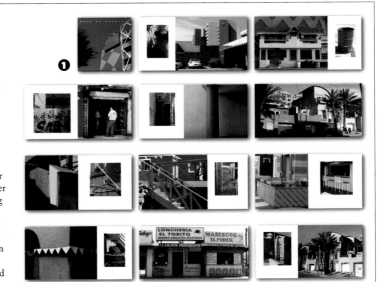

❶

Laying out a booklet for back-to-back gluing

After making a page-by-page layout of the booklet in PageMaker **1**, I made a duplicate file in which two pages were to be printed on one sheet of paper. But for the pages to be glued back-to-back in the correct order, they first needed to be shuffled as shown here **2**. Spray adhesive is useful but messy. Use it outdoors and lay down some old newspaper to protect the work surface. Avoid inhaling.

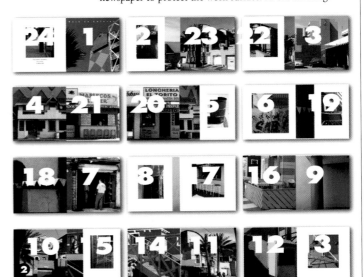

Quality Digital Prints

PRINTING ON FABRIC AND ART PAPERS

As an alternative to printing on regular paper, you can try out other types of paper and fabric for your digital photography prints. As a rule, toner-based laser printers will not tolerate paper with a rough surface, and have difficulty printing on heavy or stiff papers. Inkjet printers, however, will accept many different types of paper because their printing mechanism never comes into direct contact with the paper. They will even print on fabric.

Using a nonstandard printing paper can produce a unique and visually appealing effect, but there are some disadvantages, too. Traditional art papers cause a faster ink degradation than a standard inkjet paper, although this can be overcome to a certain extent by spraying on an ultraviolet coating, or by using special inks (see page 135). Bear in mind, however, that anything other than pure white paper will give inaccurate color reproduction.

TYPES OF ART PAPER

An inkjet printer will accept almost any type of art paper including Strathmore, Canson, and various watercolor papers. In addition, utility papers such as newsprint, brown wrapping paper, and thin packing carton paper can be used. More absorbent papers will impair the definition of the image. For the most part, these types of papers are for graphic effect rather than faithful reproduction. The farther a specialty paper is from a smooth white sheet, the more your photography will be altered by being printed on it.

TYPES OF FABRIC

If your printer will accept heavy paper, it will also accept fabric such as silk, linen, and canvas.

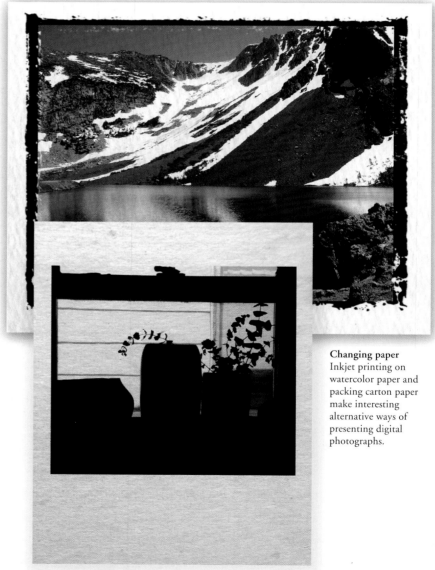

Changing paper
Inkjet printing on watercolor paper and packing carton paper make interesting alternative ways of presenting digital photographs.

Textured fabrics such as canvas should be fine-grained and very thin for best results.

SIZE LIMITATIONS

While most digital cameras generate a crisp inkjet print at 8" × 10", further enlargement can cause deterioration. You can produce a larger print, however, by splicing together a panorama from a mosaic of several digital photographs (see page 28). On a standard desktop inkjet printer the 8" limitation applies only to the width of the paper. If you use a roll of paper or fabric, the print can be any length.

There are also inkjet printers available that produce prints of 11" × 17" and beyond, but these printers should be used only for output from cameras with a resolution of greater than 4 megapixels.

HOW MANY COLORS?

Most inkjet printers use four ink colors to reproduce color photographs, but some models use six or more inks to do the same job. Secondary colors such as orange, green, violet, and indigo are added to the basic primaries of cyan, magenta, yellow, and black. In spite of the increase in color range, multiple-ink printers seem to offer no significant advantage as yet, but advances in ink technology could change this.

ARCHIVAL ISSUES

Standard inkjet printer inks may fade when exposed to daylight. Paper will also react with the ink and deteriorate over time. If you are concerned with permanence—and if you sell your work you should be—you should use archival-quality materials. Best results come from paper and inks produced by the same printer manufacturer so that the chemical interaction of ink and paper is properly balanced to give a more stable print. The relative stability of inkjet output varies considerably from manufacturer to manufacturer, and even within models of the same make.

In contrast to inkjet output, prints from toner-based printers, such as the Fiery/Cannon, are relatively stable, although their color accuracy is not yet as good as inkjet prints.

PERMANENT INKS

Standard inks are dye-based. Dyes are liquids that come in vivid, transparent colors. Unfortunately, dyes are *fugitive*—they lose their intensity over time by chemical reaction with air and light.

Specialized permanent inks that are pigment-based are available, although they are considerably more expensive than regular inks. Pigments consist of opaque particles that are ground into an extremely fine powder and suspended in a liquid medium. Pigments reproduce a narrower range of colors than dyes. The relative permanence of pigment-based inks should be weighed against the loss of color gamut and the considerable increase in cost.

PROTECTIVE COATINGS

An economical way to gain more permanence with standard inks is to apply a protective coating. Spray-on varnishes that contain ultraviolet-filtering chemicals are quite effective in slowing the degradation of dye-based inks and do not significantly affect colors. As with all sprayed products, be sure not to inhale the chemicals, working out-of-doors where possible.

Making panoramic prints
Inkjet prints can be as long as the length of the paper, but only as wide as the printer.

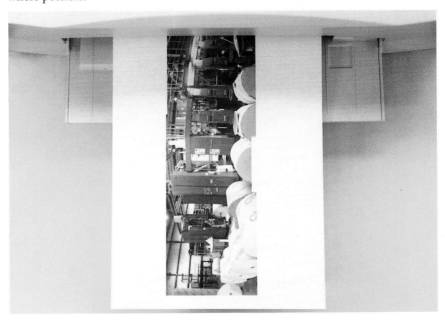

DIGITAL OUTPUT TO PHOTOGRAPHIC PAPER

Digital camera owners who do not own inkjet printers—or even a computer—can now get high-quality photographic prints from their local camera store or drugstore.

In an effort to regain a market share that has steadily been eroded by the increase of digital photography, camera stores, drugstores, and same-day processing services have adopted new film processors that can accommodate digital input.

These processing units, sometimes known as *mini labs*, use light-jet printing—a technology that combines laser beams in red, green, and blue light to etch a digital image onto regular photographic paper. The paper is then developed, fixed, and dried as in conventional film processing.

In addition to ordinary undeveloped film, the mini lab accepts CDs, Flash cards, SmartMedia, and MemorySticks from digital video cameras. The mini lab can also transfer film or digital input to CDs.

For owners of high-resolution digital cameras (greater than 4 megapixels), who are not satisfied with the standard 4" × 6" or 8" × 10" drugstore print, there are also specialized labs that can output light-jet prints up to 10" wide.

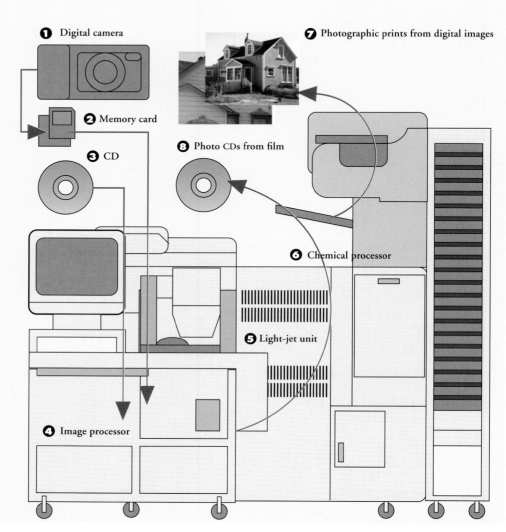

Making photographic prints from digital images

A digital camera **1** writes image files to removable memory media **2**, or to data CDs via a personal computer and CD burner **3**. These media are read by a raster image processor unit **4**. The light-jet unit exposes photographic paper **5** which is fed through a chemical processor **6** to produce regular photographic prints **7**. Digitized images from film are also archived onto CDs **8**.

11 Digital Photos in the Graphic Arts

Graphic Arts Requirements

Making a color separation
A photograph broken down into halftone dots of cyan, magenta, yellow, and black makes a color separation, where each ink color can be transferred to paper by a tandem arrangement of printing cylinders. This image is seen in extreme enlargement so that the dot pattern is clearly visible. The mesh of dots for each color is set at a different angle to avoid interference patterns.

RESOLUTION ISSUES

Very few of the digital photographs that appear in this book are larger than half a page. Most of these photos were taken with a camera that takes pictures that are only 1280 × 1024 pixels. It would take a digital photograph measuring 2125 × 2750 pixels or more to fill a page reproduced by conventional commercial offset printing—the process used to print this book.

The resolution requirements of commercial offset printing are the most exacting of all media. Digital images must be at least 250 pixels per inch (most commercial printers call for 300 pixels per inch) for successful reproduction.

A typical digital camera user is unlikely to go anywhere near a commercial printing press. Nevertheless, it is worthwhile knowing the amazing capabilities of your digital camera to reproduce your work in high quantity and high quality.

COLOR SEPARATION PROCESSES

In color offset printing, four cylinders—one for each ink color—apply ink to paper as it passes rapidly through the press. A color image must be broken down into its component colors to make printing plates for the press. This process, known as *color separation*, has been established since about 1910, and has evolved in parallel with color photography.

TRADITIONAL COLOR SEPARATION

In traditional color separation, a color transparency is exposed in a special enlarger through four different colored filters onto four pieces of high-contrast film to make the color separation. A fine mesh etched on glass, called a *halftone screen,* is placed above the film to break up the image into tiny halftone dots.

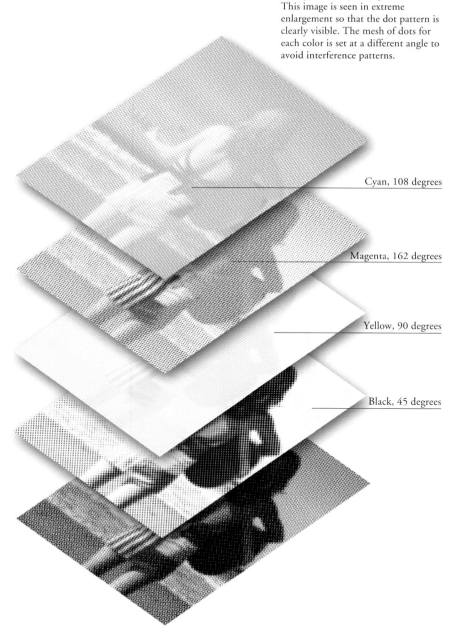

Cyan, 108 degrees

Magenta, 162 degrees

Yellow, 90 degrees

Black, 45 degrees

For each primary ink color—cyan, magenta, yellow, and black—the mesh is placed at a different angle so that the overlapping dots do not cause an interference pattern, or *moiré*. To make up all the elements that are required to print a sheet of paper on the press, skilled craftsfolk called *strippers* would patch together the separation negatives with typesetting and artwork. The assembled negatives are used to expose the image onto light-sensitive lithographic printing plates, which, when processed, contain a pattern of tiny dots that attract ink.

Running a printing press is an operation in which mistakes can be costly. That is why special color proof prints are usually made from the same film that will be used to make the printing plates and are carefully checked before the plates are made.

DIGITAL COLOR SEPARATION

Why go into all this detail about an obsolete technology? It's important to appreciate that commercial printing is a mature industry with many traditions, procedures, and business practices. Today the industry is undergoing a rapid transformation, driven by the digitization of printing materials. Many of the old crafts that stood between the originator of the printed material and the printing press—the typesetter, the color separator, the stripper—have disappeared. Even film is being supplanted by platemaking directly from the computer file.

RGB OR CYMK?

The initial format for digital camera images is RGB, but commercial printing requires the CMYK format for color images. You can convert your RGB images to CMYK in Photoshop (not Photoshop Elements), but be careful! You are now the color separator, and must take responsibility for esoteric settings, such as undercolor removal and gray component replacement, which govern the amount of black ink in dark colors. The type of press and the type of paper are also factors to be considered.

Always check with your printer before making conversions, or—better yet—have the printer make them for you.

Reproducing digital images by offset printing
This greatly simplified diagram shows the steps that take a digital image from a computer document to high-quality printing.

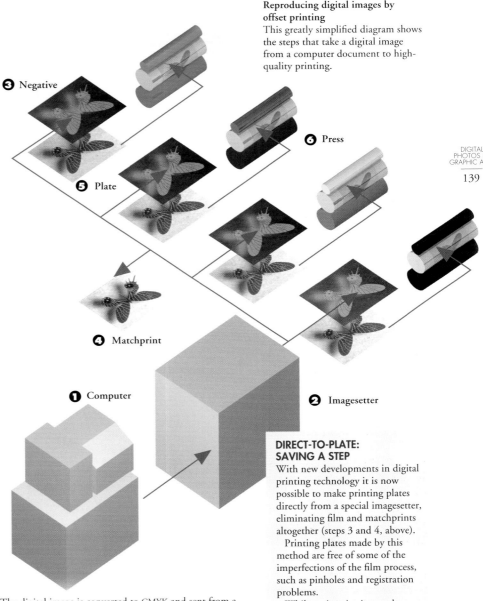

❸ Negative

❻ Press

❺ Plate

❹ Matchprint

❶ Computer

❷ Imagesetter

The digital image is converted to CMYK and sent from a computer terminal, **1** to the imagesetter **2**. The imagesetter processes the digital file and uses a laser to expose four film negatives **3**, one for each color. The negatives are checked by making a *matchprint* **4**, a laminated sandwich of four thin positive transparencies, one layer for each color. If the color is accurate and no mistakes are found, the negatives are used to expose a set of printing plates **5**, which are then hung on the four cylinders of the press **6**.

DIRECT-TO-PLATE: SAVING A STEP

With new developments in digital printing technology it is now possible to make printing plates directly from a special imagesetter, eliminating film and matchprints altogether (steps 3 and 4, above).

Printing plates made by this method are free of some of the imperfections of the film process, such as pinholes and registration problems.

While savings in time and cost are considerable, great care must be taken in preparing the image files because the intermediate checkpoints no longer exist. Color proofs can be made from the computer file before plates are made, but these are less accurate than matchprints made from film.

Designing with Digital Photos

Digital sketching
This magazine cover concept derives from a digital photo of a full-length figure overlayed with several photos of urban textures. Although this design makes an attractive mock-up, it would have to be re-created with conventional photography or high-end digital photography to conform to industry standards for a magazine cover.

MAKING EDITORIAL LAYOUTS

The term "editorial" in design refers to nonadvertising graphics. It includes books, journals, magazines, and newsletters. An editorial art director combines typography, illustration, and photography to provide visual support to the editorial material.

Digital photography is playing an increasingly important role in editorial design, but because industry standards are very high, a digital photographer quickly runs up against a barrier. Publishers' concerns about the quality of digital photography today echo the reservations about desktop publishing of two decades ago. Acceptance of new technology tends to follow a certain pattern: it is first embraced by the amateur enthusiast and later adopted by the innovative professional. Ultimately it becomes mainstream practice.

DIGITAL PHOTOGRAPHY AS A SKETCH TOOL

One of the most frustrating problems in art direction is how to present several alternative photographic concepts for approval by a client without incurring the expense of producing the photographs themselves, especially since most of them will be discarded. An illustrator could present ideas as pencil sketches, but a photographer had no equivalent means at his disposal before digital photography made photographic "sketching" possible.

Low-resolution "sketch" photography with a digital camera, in combination with image-editing software, can streamline the creative process by giving the client, the designer, and the photographer a more accurate prediction of the final image.

Unlike conventional photographs, digital photos do not have to be processed and then scanned. Since almost all graphic design is done by computer today, there is great expediency in having your photograph in a computer-compatible form right from the start.

DIGITAL PHOTOGRAPHY AS FINAL IMAGE

With the convenience and time-saving advantages of digital photography, it's very tempting to use it directly in publications. Sometimes there's a tight deadline, a tight budget—or both! Can digital photography be used as an acceptable substitute for conventional photography? In most circumstances it can.

It's unrealistic to expect a digital camera at the 4 megapixel resolution range to produce pictures that can fill a magazine page. However, large photos are not always necessary or desirable in editorial layouts. A small image with a large amount of space around it can be just as dramatic as a large one. It's also possible to tell a story with a group of smaller pictures that present a variety of visual viewpoints.

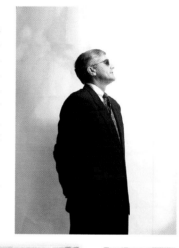

Making editorial layouts

Magazine and journal pages are full of advertisements, and the editorial content often has to flow around the ads. It's important to keep the editorial layout clean and simple to set off the ads. Small digital photos can be very effective in decorating the narrow-column pages that contain fractional-page ads. Feature articles can be laid out with digital photos that are ⅔ of a page or less, but most digital photos can't be stretched larger. *Layout and photos by Tim Odam.*

*Aristo*life

In search of the perfect getaway

We sent our couple to Ston Easton Park in Somerset, to find the perfect English country retreat.

Sed diam nonummy nibh euismod tincidunt ut laoreet dolore magna aliquam erat volutpat. Duis autem vel eum iriure dolor in hendrerit in vulputate velit esse molestie consequat, vel illum dolore eu feugiat nulla facilisis at vero eros et accumsan et iusto odio dignissim qui blandit praesent luptatum zzril delenit augue duis dolore te feugait nulla facilisi. Lorem ipsum dolor sit amet, consectetuer adipiscing elit, sed diam nonummy nibh euismod tincidunt ut laoreet dolore magna aliquam erat volutpat. Duis autem vel eum iriure dolor in hendrerit in vulputate velit esse molestie consequat, vel illum dolore eu feugiat nulla facilisis at vero eros et accumsan et iusto odio dignissim qui blandit praesent luptatum zzril delenit augue duis dolore te feugait nulla facilisi. Lorem ipsum dolor sit amet, consectetuer adipiscing elit, sed

san et iusto odio dignissim qui blandit praesent luptatum zzril delenit augue duis dolore te feugait nulla facilisi. Lorem ipsum dolor sit amet, consectetuer adipiscing elit, sed diam nonummy nibh euismod tincidunt ut laoreet dolore magna aliquam erat volutpat. Duis autem vel eum iriure dolor in hendrerit in vulputate velit esse molestie consequat, vel illum dolore eu feugiat nulla facilisis at vero eros et accumsan et iusto odio dignissim qui blandit praesent luptatum zzril delenit augue duis dolore te feugait nulla facilisi. Lorem ipsum dolor sit amet, consectetuer adipiscing elit, sed diam nonummy nibh euismod tincidunt ut laoreet dolore magna aliquam erat volutpat. Duis autem vel eum iriure dolor in hendrerit in vulputate velit esse molestie consequat, vel illum dolore eu feugiat nulla facilisis at vero eros et accumsan et iusto odio dignissim qui blandit praesent luptatum zzril delenit augue duis dolore te feugait nulla facilisi. Lorem ipsum dolor sit amet, consectetuer adipiscing elit, sed diam nonummy nibh euismod tincidunt ut laoreet dolore magna aliquam erat volutpat.

How did the venue shape up in our getaway test?

Duis autem vel eum iriure dolor in hendrerit in vulputate velit esse molestie consequat, vel illum dolore eu feugiat nulla facilisis at vero eros et accumsan et iusto odio dignissim qui blandit praesent luptatum zzril delenit augue duis dolore te feugait nulla facilisi. Lorem ipsum dolor sit amet, consectetuer adipiscing elit, sed diam nonummy nibh euismod tincidunt ut laoreet dolore magna aliquam erat volutpat. Duis autem vel eum iriure dolor in hendrerit in vulputate velit esse molestie consequat, vel illum dolore eu feugiat nulla facilisis at vero eros et accumsan et iusto odio dignissim qui blandit praesent luptatum zzril delenit augue duis dolore te feugait nulla facilisi.

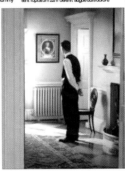

augue duis dolore te feugait nulla facilisi. Lorem ipsum dolor sit amet, consectetuer adipiscing elit, sed diam nonummy nibh euismod tincidunt ut laoreet dolore magna aliquam erat volutpat. Duis autem vel eum iriure dolor in hendrerit in vulputate velit esse molestie consequat, vel illum dolore eu feugiat nulla facilisis at vero eros et accumsan et iusto odio dignissim qui blandit praesent luptatum zzril delenit augue duis dolore

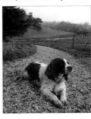

Repeating a rotation
For this cover I made an unusual abstract geometric design. A digital photo of street architecture served as a starting point for a composite image made up of successive rotations of the original picture in Photoshop Elements. Each layer used the Lighten mode to prevent density buildup.

Combining images
To make this chemistry book cover I combined a tabletop still life of a molecular model with a photo of clouds. In Photoshop Elements the molecule layer was used in the Exclusion mode.

Synergistic Perception

MICHEAL GOSNEY

Environmental Chemistry

A. N. McCLOUD

MAKING BOOK COVERS

A typical book cover measures 6" × 9"— the perfect format for a 4 megapixel digital camera image that will be reproduced by commercial offset printing. By combining several images, larger format covers can also be created. Even where the absolute size of the book cover precludes the use of a single digital photo, the digital camera is still very useful as a sketch tool to simulate several different cover ideas for a presentation.

Making a large-format book cover from many images
A panorama of overlapping digital photos of the contemporary town center underlies an old postcard of the same location. A close-up shell image adds the finishing touch.

DIGITAL
PHOTOS IN
GRAPHIC ARTS

143

NANCY HANKS EWING

DELMAR

LOOKING ✦ BACK ✦

HIGHWAY AND FIFTEENTH AVE.
DEL MAR, CALIF.

PRODUCING CD COVERS

The cost of producing and marketing an audio CD has been rapidly falling as computer technology has advanced. Meanwhile, with so many independent and self-made recordings coming onto the market, the demand for creative CD covers has increased. Measuring less than 5" square, CD covers are well within the resolution capability of most digital cameras.

Aided by a digital camera, a personal computer, and some image-editing and layout software, a small graphic design business can offer a highly competitive service for designing and producing CD covers. Visually literate musicians will also find the digital camera handy for making their own covers.

Putting it all together
The cover photo, the inner folder, and the disc graphic should all relate thematically.

DO-IT-YOURSELF CD PRINTING: BE YOUR OWN RECORDING LABEL

All over the world, musicians are making their own albums—many of them better quality and more original than anything you'll find on a major record label. With an inkjet printer, a CD burner, and a set of pre-cut labels you can also produce a homemade album that's every bit as good as a commercial product. In fact, adhesive inkjet disk labels give better quality printing than their commercial counterparts.

A complete set of labels and inserts with templates for Macintosh and Windows is available from www.neato.com.

Piano Typesetting
The typography on a CD cover can be small and hidden within the image.

Practicing scales
The juxtaposition of objects at different scales produces a surrealistic effect.

Setting in stone
A piece of sculpture makes a strikingly different portrait treatment.

Making a mix
Mixing a digital photo with a royalty-free background image adds another dimension.

MAKING ADVERTISING LAYOUTS AND FLYERS

Advertising is perhaps a mixed blessing in our culture. An essential tool of business, it is also a source of annoyance that has been with us for centuries. Just as a person walking in a town square in the Middle Ages would have been harassed by street merchants and beggars, today a person reading a newspaper is bombarded with advertising.

The reason that advertising not only survives but thrives is that it actually works. True, a vast majority will ignore your message, but there will be some who will be keenly interested in your product or service, who without advertising would not be aware of its existence.

In newspapers, magazines, and other publications the advertising message has to compete with other advertisements and editorial material. In flyers and direct mail, the message stands alone.

A digital photo can work as well in any advertising layout, provided its size is 8" × 10" or less. In most advertising layouts, the image does not fill the whole area of the ad in order to leave room for headlines and copy. A photograph doesn't merely show the product, it can show an attribute of it, or it can be used to convey a metaphorical message. But, above all, it should be clear and uncomplicated, and it should make its point instantly.

Using a digital product shot
One of the humblest approaches to making an ad is to show the product and describe what is does.

Mixing metaphors
A photograph can be used in advertising symbolically or allegorically. Even if the metaphor is a cliché, an arresting image will hold the reader's attention long enough to deliver the message.

In these two examples, I used Photoshop Elements filters to add a glow to the light bulb and to accentuate the sunbeams in the sky.

Making a business card
Digital photos can make snappy
business cards. Even low-resolution
camera images can be used
successfully in such a small area.

Making a third-page magazine ad
This hotel ad is an example of classic
advertising layout: photo, headline,
supporting text, and logo—arranged
in simple, symmetrical sequence.
The digital photography combines an
outside shot with a close-up detail.

Making a flyer
A color digital photo can make an
attractive flyer, reproduced by short-
run digital offset printing or color
copying. A circular portion of the
image was rotated slightly to suggest
misalignment.

PROMOTING PRODUCTS AND SERVICES

The digital camera is a very powerful tool in crafting promotional materials for small businesses and municipalities. Short-run color offset printing from computer-generated documents makes it possible to produce and update marketing materials economically and quickly.

In a catalog, leaflet, or menu, the pictures must tell part of the story, but the designer and copywriter rely on words to provide specific information about the products and services that the photographs display. Thus, the typesetting should be fully integrated with the photography, so they go together as one.

For variety, rectangular photos can be mixed with silhouettes. In some cases the images can overlap, giving a sense of depth to the layout. Don't hesitate to use image-editing to remove distracting background elements, and to correct for perspective distortion.

For a catalog of products, the same images that appear in the printed piece can be readily adapted for use in an online catalog. (For more about digital photography and the Web, see page 158.)

Making a fold-out leaflet
With a good layout, any number of on-the-spot digital photographs can be combined to make a three-panel fold-out leaflet or brochure.

Putting the product in the public eye
Individual images can look good on a simple white background in this straightforward catalog concept for kites **1**. Related to catalog layouts, menus also display products. **2** Here, a decorative tablecloth graphic background sets off the photos. The shadows under the plate blend with the background. **3** A point-of-purchase card combines a table-top still life of the product with lettering whose colors are taken from the parts of the image.

Papaya Salad

Freshly sliced tropical papayas on a bed of organic red and green lettuce and spinach, garnished with beets, garlic and juicy lemon.

4.95

Chef's Favorite

Sunflower Nori Rolls

Zesty sunflower seed filling, cucumber, carrot and a touch of beet, rolled in nori seaweed.

6.95

Small kites, big value!

Mini Delta
Small kites, big value! Ripstop nylon 20" x 10". Includes line and tails. No. 18310 $4.95

Mini Box
Small kites, big value! Ripstop nylon 10" x 9". Includes line. No. 18320 $6.50

Mini Diamond
Small kites, big value! Ripstop nylon 10" x 10". Includes tail and line. No. 18300 $3.50

Chummy Buns
$1.98

Stylizing a single image
In keeping with the traditional travel poster of the 1920s, a posterization technique, in this case the Photoshop/Elements Cutout filter, was used to make a large-scale, bold design from a single digital photograph.

Making a multiple-image poster
Splicing together a series of close-up shots is one way to overcome the resolution limitations of digital photography, as shown in this whimsical poster concept.

MAKING POSTERS

The role of the poster changed during the 20th century. With the advent of the motorcar, as the wall poster began to be replaced by the giant billboard, the poster still remained an important publicity medium for films, cultural events, travel, and commercial products. By the 1960s the poster had moved away from outdoor advertising and became mainly an item of decor.

The problem that a poster presents to a digital photographer is its large size. No single image from a 4 megapixel digital camera can be enlarged to poster size without some loss of quality. Some ways of working around the problem include making montages of multiple shots and using posterization techniques (discussed on page 100) to stylize the image.

12 Digital Photos on the Screen

On-Screen Requirements

RESOLUTION FOR THE COMPUTER SCREEN AND TV MONITOR

In contrast to the stringent reproduction standards of graphic arts printing, the screen environment is favorable for digital camera images, with many cameras producing images that are more than ample for on-screen viewing. In fact, it will usually be necessary to *reduce* the number of pixels in an image, just to get it to fit on the screen.

Determining the correct resolution for the screen is easy: 72 pixels per inch is the standard for on-screen displays, whether for slideshows, multimedia presentations, or output for video or DVD. And no matter what the size of the viewing monitor, the standard proportions of a multimedia image is 4:3. Web pages are an exception because scrolling imposes no absolute limit on image size or proportion.

CHANGING THE RESOLUTION OF AN IMAGE

To make a digital camera image fit a computer screen you'll probably need to change both the image size and the image resolution. Image *size* and image *resolution* are related terms and are easily confused with each other. A common source of this confusion lies in the fact that a pixel is not a unit of measurement like an inch or a millimeter. A pixel does not have a fixed size and can be enlarged or reduced as needed.

Resolution to spare
A typical digital camera image far exceeds the available screen area of most computer monitors when they are configured at the standard 72 pixels per inch resolution.

DISPLAY	PIXELS
NTSC video	720 × 480
13" Monitor	800 × 600
17" Monitor	1024 × 768
1.4 Megapixels	1280 × 1040
21" Monitor	1920 × 1440
4 Megapixels	2288 × 1712
5.7 Megapixel	2560 × 1920

IMAGE SIZE

Image size, expressed in pixels, refers to the absolute dimensions of the image in pixels, regardless of the resolution. A digital camera may have settings that allow for several different image sizes to be recorded.

IMAGE RESOLUTION

Image resolution, expressed as pixels per inch, indicates the size of the pixels that form the image. There is no current standard resolution for images recorded by digital cameras. Some may record at 72 pixels per inch, others at 144 pixels per inch, and yet others at 240 pixels per inch and more.

IMAGE PROPORTION

While most digital cameras produce images that are 4:3 in proportion, many have panoramic format options. Some cropping or *letterboxing*—allowing blank space above and below a horizontal image—may be necessary to make these images conform to various monitor or projection proportions.

IMAGE SIZE AND CANVAS SIZE

When we change the *image size* of a photo with the option "Resample Image" checked in the dialog box, the entire image is reduced or expanded, rearranging its pixels. When we change the *canvas size* of a photo, we are adding null pixels, or discarding pixels at the periphery of an image, without causing it to be resampled. (Cropping an image will reduce, but not expand, its canvas size.)

CHANGING THE RESOLUTION AND PROPORTION OF AN IMAGE FOR ON-SCREEN USE

To make a digital camera image fit a typical 17" monitor screen of 1024 x 768 pixels: in Photoshop, choose Image > Image Size, or in Photoshop Elements, Image > Resize > Image size.

First, be sure that the Constrain Proportions and Resample Image buttons are checked.

Notice the pixel values. Depending on the way your camera saves its files you may see different values than the ones shown here, particularly in the bottom dialog showing Document Size. The first change you make is in this dialog box. Change the ppi value to 72 ppi (on-screen resolution), make sure that height and width are linked (notice the chain icons), then change the width pixel values in the top half of the dialog box to suit your viewing needs—in this case 1024 pixels.

After clicking OK, you may find the Pixel Dimensions Height is not the desired 768 because the camera's images may not be in exact proportion with the monitor.

To attain the desired image height you can change the canvas size of the image. In Photoshop, select Image > Canvas Size, or in Photoshop Elements, Image > Resize > Canvas Size.

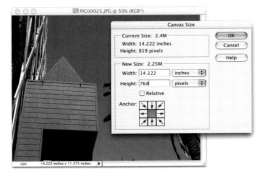

In the New Size dialog box, select Pixels in the pop-up window. Now type in the desired image height in pixels—769 in this case. The 8-way Anchor arrows indicate that an equal amount will be trimmed above and below the image, but you can click on the upper or lower squares to remove only the top or the bottom of the image. After clicking OK, a warning will appear to remind you that you are actually deleting a part of your image. If you are satisfied with your choice, click Proceed.

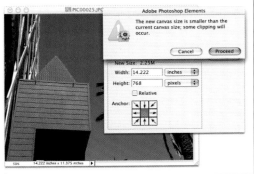

Slideshows and Presentations

CREATING A SIMPLE SLIDESHOW

A computer-generated slideshow presents a series of images in a prearranged order on a computer screen. Depending on the software used, transitions and a soundtrack are also possible.

PREPARING IMAGES FOR A SLIDESHOW

No matter what program you will use for your slideshow, there are some important preparations:

• Create a new folder exclusively for your slideshow and be sure that all the files that you want to include are there—and no other files. Examine each image in Photoshop or Photoshop Elements, and if necessary rotate or crop them.

• You may also need to renumber your images to put them in the order you want them to appear. Use zeros in front of single digit numbers and double zeros if you have more than a hundred photos in your show.

I-PHOTO

I-Photo is a digital camera utility that is part of the Macintosh operating system. Whenever you use I-Photo to capture images from a digital camera the files are stored in a database or "Photo Library." I-Photo gives you access to the Photo Library and provides for images to be assembled into separate "Albums," which can be viewed as a slideshow with music.

ADOBE PHOTOSHOP ELEMENTS AND ACROBAT

Choose File > Automation Tools > PDF Slideshow. Go to the folder you have prepared for your slideshow, and add the source files to the list. After selecting an output folder, the program automatically resizes each image and creates a PDF Slideshow file, which can be opened in Adobe Acrobat. Like I-Photo, once started, the Acrobat Slideshow cannot be stopped without exiting the program.

SLIDESHOW FREEWARE

Some of the most capable slideshow utilities are actually free. KPT QuickShow for Macintosh and Slider for Windows are two examples. To create a slideshow with KPT QuickShow, simply drag a copy of the program into the images folder and launch it. QuickShow's navigation controls are accessible by pressing the Tab key, and can specify transitions, pacing, and image size.

Making a slideshow in I-Photo
Images are dragged into a staging area, then viewed as a slideshow by clicking on the Play button.

Making a slideshow in Photoshop Elements
Slideshow preparation in Photoshop Elements (File > Automation Tools > PDF Slideshow) is as simple as lining up the images you want by using the Browse button. You can also make a slideshow from a series of files that are currently open. Playback requires Adobe Acrobat.

MAKING POWERPOINT PRESENTATIONS

PowerPoint is probably the most widely used cross-platform application for creating slideshows and presentations.

Slideshows and presentations can be displayed on a computer monitor or on a digital projector, which plugs into the VGA port of your computer and can deliver your information to a wider audience (a room of 100 people, for instance). A typical digital projector is capable of displaying 800 × 600 pixels, so you might want to save your images at this size for full-screen presentation. Batch processing will speed up this process (see sidebar on this page).

If you have been shooting your images at high resolution they will be far higher in resolution than that necessary for on-screen presentation. Whether producing a simple slideshow with imagery alone, or a presentation with text, graphics, sound, and moving images, the resolution of all your imagery need only be 72 pixels per inch. PowerPoint accepts image files in JPEG format and audio files in WAV format.

BATCH PROCESSING IN PHOTOSHOP/PHOTOSHOP ELEMENTS

When preparing a slideshow or presentation, you may have a large number of digital camera images that need changes in orientation, resolution, and image size. To expedite this somewhat tedious chore, you can use the Photoshop/Elements Actions commands to automate the process.

An *Action* is any combination of transformations applied to an image file (for example: Rotate 90° Clockwise + Resolution = 72 pixels per inch) that can be recorded and given a name, such as "DownrezRotateClockwise" in the Actions palette. A *Batch* process is the application of a given Action to all the files in a specified folder.

To make the PowerPoint presentation shown on this page, we set up two Batch processes: one for vertical shots and another for landscape shots (File > Automate > Batch) and chose the folders and actions to be performed on them and where the modified files should be saved. In this case, our Actions called for a maximum width of 800 pixels for landscape shots (height adjusts automatically) and maximum height of 600 pixels (width automatic) for portrait.

INCORPORATING AUDIO AND GRAPHICS

PowerPoint offers you a variety of wipes and dissolves to create transitions between shots (Slide Show > Slide Transition). You can also add a soundtrack from stock sounds (Insert > Movies and Sounds > Sound from Gallery), or record your own narration (Slide Show > Record Narration). You can record while viewing the slideshow on screen. Once recorded, timings can be changed to fine tune your show (Slide Show > Rehearse Timings). If you have a CD with music you'd like to use, you can link tracks from it to your show (Insert > Movies and Sound > Play CD Audio Track).

Assembling a slideshow in PowerPoint

In Microsoft PowerPoint, you can choose from a selection of background motifs or "themes," insert transitions, such as wipes and cross-fades, and add bullet lists, titles, charts and graphs, film clips, music, narration, and sound effects to create professional-looking slideshows and presentations. *Photos by Tim Odam.*

Using Digital Photography Online

E-MAIL

The old saying "a picture is worth a thousand words" was never more true than today with e-mail allowing images to enhance our ability to communicate with text. The saying is also correct in pointing out the difference in bandwidth requirements between images and text—although it's off by an order of magnitude.

There is little doubt that the convenience of moving digital images instantly anywhere around the world has been one of the principal driving forces behind the popularity of digital photography.

E-MAIL ETIQUETTE

There are many different e-mail programs in use, as well as different computer platforms. So it's wise to remember that not all potential e-mail recipients are configured to receive photos as attachments or embedded in e-mail messages. Likewise, there are wide variations in connection speed with relatively slow telephone lines competing with high-speed cable access.

So before you decide to send that magnificent digital greeting card to all your friends and relatives, be sure that you

Sending a digital photo as an e-mail attachment
Attaching an image to an e-mail message is simple. In America Online, for example, you would first compose a message, click the Attachments tab, then navigate to the file you wish to attach and click the Attach button.

The recipient would click on the icon of the attached image to open it in a separate window, or drag the icon to the desktop or to a folder to copy it for later viewing. *Photo by Jack Davis.*

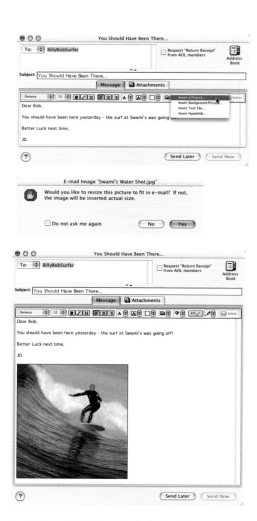

Enclosing a digital photo in the body of an e-mail message
You can place an image at an insertion point in the text of your message. America Online also provides an automatic resizing funtion, which, if enabled, will ensure that the entire image is contained within the message window.
Photo by Jack Davis.

will not burden anyone with a huge file that could take hours to download. When in doubt, ask before you transmit.

COMPRESSION AND FILE FORMATS

In order to send images with tolerable downloading times, whether by e-mail or as part of a web page, some form of image compression is required. Most image compression is a *lossy* process—in other words, the compressed file contains less information than the original, and the difference between the two versions will be noticeable.

Many digital cameras save images in some kind of compressed format that may not require any further compression for e-mail transmission.

Image compression formats fall roughly into two categories: specific image compression formats, such as JPEG and GIF, which can be opened directly in any image-editing software, and general file compression algorithms, such as Stuffit or Zip, that can be applied to any type of computer file but which require a separate program to compress and uncompress them.

JPEG FILES

JPEG (Joint Photographic Experts Group) compression simplifies image data and may result in noticeable loss of quality. (The terms *JPEG* and *JPG* are interchangeable.) Many digital cameras use a similar type of compression to capture their original images. JPEG images are optimized for photo-graphs and contain 24 bit color information. Compression artifacts (see page 82) are noticeable, especially at low-quality (high compression) settings.

GIF FILES

GIF compression uses *indexed color* to achieve image compression and contain 8 bit color information. Most images contain only a fraction of the more than 16 million colors that the computer can recognize. Indexing analyzes the number of distinct colors in an image and reallocates them to a restricted palette of 256 colors, thus reducing file size.

Unlike JPEGs, GIFs support transparency, but are optimized for graphics, typesetting, and solid color areas. If your image file incorporates lettering, or needs to be silhouetted against a background, GIF is a good format to use.

PNG FILES

PNG is an image format that has been developed especially for the World Wide Web. Like JPEG, it supports 16 million colors, and like GIF, it also supports transparency. However, not all web browsers can recognize PNG files.

Photoshop and Photoshop Elements can read and generate files in many formats, including those described above.

PDF FILES

If you like to place images in a layout program, such as Adobe PageMaker, with typesetting and other graphics, you can export pages with Adobe Acrobat's PDF format, which can be e-mailed or linked to a web page.

IMAGE COMPRESSION: TWO METHODS

How JPEG compression works

Digital images consist of a matrix of pixels of different colors. Each pixel has a different memory location and a digital number that represents its exact color **1**. In some compression methods, the computer is instructed to look for adjacent or contiguous pixels that have the same numerical value, and writes special code to define the area covered by that particular color **2**. This special coding reduces the amount of digital information necessary to store an image.

In reality, with over 16 million possible colors, the likelihood of two adjacent pixels being exactly the same color is relatively slim. So compression algorithms look for adjacent pixels of *similar*, rather than *identical* color. The degree of similarity that is allowed determines the amount of compression. The process of averaging can result in detectable "blocks" of color.

How GIF compression works

The GIF file format achieves compression by reducing the number of colors in a digital camera image file. This process, known as indexing, has its roots in the early days of personal computers when only a limited number of colors could be displayed. The original digital camera image **3** contains only a fraction of the available 16 million colors. The special color palette created by indexing uses only 256 colors of a particular palette **4**. "Dithering"—a checkerboard pattern of alternating colors—creates the illusion of intermediate colors.

DIGITAL PHOTOGRAPHY IN WEB DESIGN

The Internet is an outgrowth of a military system capable of withstanding nuclear war. It was designed to provide redundant links between computers. Today the Internet, or World Wide Web, consists of a global network of computer servers, linked to personal computers via modem or cable. The common code for web pages is *html*, or Hyper Text Markup Language, which runs on any computer platform.

Accessible through special *browser* software, the Web is primarily a text-driven, rather than an image-driven, medium. Powerful search engines seek out key words and can hone in on any topic imaginable.

Constructing web pages can be frustrating for designers who are accustomed to the degree of control that is possible in print media. Images may shift position and text reflow at the will of the viewer. The best solution is often the simplest: Avoid overloading pages with material that forces scrolling; break up the document into smaller page sequences; one medium sized graphic downloads faster than several small ones; larger images can be broken up into *slices*—a set of adjacent image tiles that build up the larger image on the screen from many smaller, faster loading pieces. (See page 160.)

THE SCREEN VERSUS THE PAGE

Most of the digital photographs printed in this book are intended for print media. Although the much-heralded demise of print is proving to be as elusive as the paperless office, electronic media are nevertheless advancing rapidly, propelled mainly by the phenomenal growth of the Internet.

Photographers and designers are now expected to produce everything from on-screen slideshows to web pages, DVDs and interactive CD-ROMs, or even animation. Digital photographs, used with attention to sound design principles, can be very helpful in designing for the screen.

There are fundamental differences between the page and the screen, but an absence of clutter and an elegant simplicity are criteria that apply equally to both media. In other words, "less is

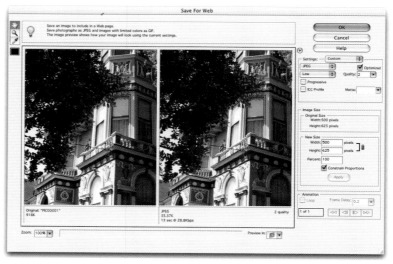

Saving for the web
"Save For Web" is an option under the File menu in both Photoshop and Photoshop Elements. This useful function takes you to a screen like this. The conrols on the right allow you to specify what file format you want, how much compression as well as pixel dimension and resolution. A split screen lets you see the compressed file in comparison to the original. Save For Web is equally useful for preparing images for e-mail transmission if your e-mail program does not come with file reduction and compression features.

Using a metaphor
The visual information in an interactive medium does not always have to be literal. A digital photo can often be matched with a metaphorical message.

MAKING A WEB PHOTO GALLERY IN PHOTOSHOP ELEMENTS

Photoshop Elements provides a convenient way to make web pages to display your digital photographs online. First be sure that all the images you want to show are all in the same folder and in the correct numerical order. No other files should be in that folder. Go to File > Create Web Photo Gallery. Choose from among 15 preset web pages, and specify fonts, font sizes, and other details that you want to appear on the page. Navigate to your source folder and specify a target folder. The program will automatically resize your images and create a folder of linked files ready to upload.

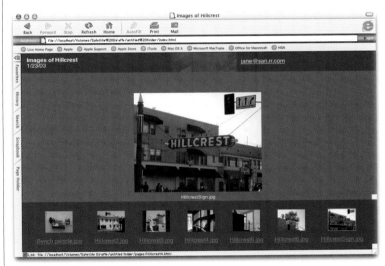

more." This dictum is especially important for on-screen graphics because the screen simply cannot support as much information density as the printed page. Viewing images on a monitor is harder on the eyes because of the screen flicker and also because the image is viewed by light transmitted from cathode rays rather than that reflected by a piece of paper. These factors are especially important when it comes to text.

PRODUCING A TACTILE LOOK

Another difference between the printed page and the screen is that screens are usually interactive; that is, they contain navigational buttons and other elements that must be "touched" with the mouse cursor so that the viewer can move from one screen to another within the presentation.

ANYTHING CAN BE A BUTTON

A contrasting approach is to actually hide buttons and hot spots within the image: The user becomes aware of a control area only when the "arrow" cursor changes to a "finger" while exploring. A cursor arrow passing over a doorway, for example, might turn into a finger, leading to a room beyond when pressed.

Rollovers, an advanced technique that causes the underlying image to change when the cursor passes over it can add even greater sophistication to an interactive web page.

CHOOSING THE RIGHT SOFTWARE FOR A WEB SITE DESIGN

There are purists that insist on making web pages by writing in HTML code, but this is unnecessary today, since many word processing and page layout programs come with web page creation tools. Some useful web page templates are also included with operating systems.

Other specialized web site design programs such as Adobe GoLive and Macromedia Dreamweaver offer a full range of tools for creating unique and original web pages. If your design is primarily visual, rather than text, it might make more sense to build your page entirely in Photoshop or Photoshop Elements, which can also generate HTML files.

PREPARING PHOTOS FOR A WEB PAGE

In general, keep images small—500 pixels or less in width, and at 72 pixels per inch resolution. Photos seem larger in the context of a web page than in Photoshop or Photoshop Elements. To accommodate smaller computer monitors, a single image should be no larger than 800 pixels wide and 600 pixels high. Unnecessary scrolling dilutes the graphic impact of an oversize image.

SILHOUETTING AND TRANSPARENCY

The GIF format supports transparency, allowing a silhouetted image to "float" above a colored background. Unfortunately, the restricted color palette of GIF files can cause fringing and stair-stepped edges around the edges of the image. This drawback is less apparent with PNG files.

BACKGROUND IMAGES

You can place a background image on a web page either as an overall design or as a pattern of repeating tiles. Pale, low contrast images work best. Once popular, background images have fallen out of favor because they increase load time without contributing significantly to the content of a web page.

USING SLICES TO MAKE A WEB PAGE

With its Slices function, Photoshop's companion program, ImageReady, treats foreground and background as an integral file. It creates an HTML table filled with sections of the original file, neatly fitted together like pieces of a jigsaw puzzle. The pieces quickly come together as the browser rebuilds the image seamlessly on the screen.

Making slices in Photoshop and ImageReady

In this example, several digital photos have been combined in Photoshop with a banner **1**. Note the ruler guides marking the seams between the images. The arrow at the bottom of the Tool palette **2** opens ImageReady. In ImageReady, the guides provide the structure for a table of slices **3**. Choose Slices > Create Slices from Guides. File > Save Optimized creates a set of numbered web-optimized tiles plus an HTML document which can be edited in a web authoring program such as Adobe GoLive. Slices can be made into links or buttons. You can also add text by removing selected slices **4**. Before uploading, always preview the HTML file in an actual web browser.

START WITH
A DIGITAL
CAMERA

160

PUTTING PRODUCTS AND SERVICES ON THE WEB

Your digital camera is perhaps the most important tool if you want to make a web site promoting or selling a product or service. More often than not, photographing a product against a plain white background shows it to best advantage.

When arranging your images on a web page it's useful to remember this famous design maxim: less is more. Try not overwhelm the viewer with dozens of images. A few well-chosen ones with plenty of space around them works best.

The convention in product display on the web is that all pictures are clickable, taking the viewer to a larger, more detailed view. Carrying banners, button bars, and other graphic elements from page to page in the same position and size brings about a smoother experience as the viewer clicks through the site.

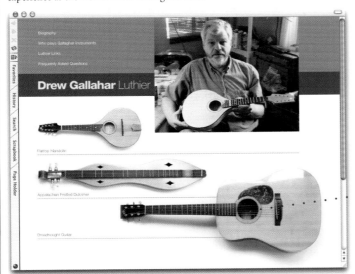

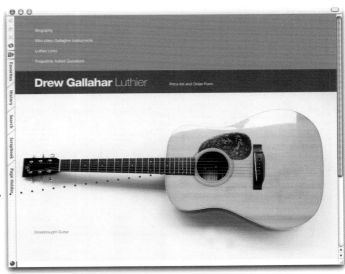

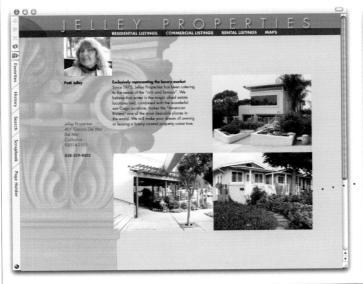

ANIMATING WEB IMAGES

One is scarcely able to log on to the Internet nowadays without being bombarded with flashing buttons and pulsating advertisements. These annoying side effects are part of a trend toward motion on the Internet. Web designers are producing original and eye-catching work by using various animation formats, and their ideas are catching on fast as browsers evolve and high-speed connections become more widespread.

ANIMATED GIF

An animated GIF file is essentially a set of images that are all the same size, strung together in sequence in a single file. Most web browsers support Animated GIF files. If you have great patience you can make stop-action image sequences with a digital camera (claymation) by manipulating props. Some digital cameras can also produce video streams of limited duration. These animation or video sequences can be converted to Animated GIF format in Adobe Premiere, Live Picture, and Apple QuickTime Pro, and embedded in web pages.

SWF

SWF files—otherwise known as *Flash* files—are vector-based animation files which also support digital photographic images. Their crisp appearance and smooth motion make them popular. Programs such as Adobe LivePicture and Macromedia Flash produce SWF files. Vector graphics are capable of being scaled and distorted without losing image quality. They also support variable opacity, allowing complex layering. Not all web browsers can yet handle SWF files.

Inserting a SWF animation into a web page

Digital camera stills were placed onto a timeline in Adobe LiveMotion and treated with pans, zooms, and crossfades to make a SWF animation. The sliced Photoshop/ImageReady layout was designed to accommodate the SWF insert. (Note the extra tall combined slice 03. It prevents slipping when slice 05 is removed.)

Digital Photos in Interactive Media

INTERACTIVE CD-ROM

Introduced in the early 1990s, this medium was the first practical means of distributing and displaying high-resolution images and audio. Whereas a web page appears within the shell of an Internet browser, every pixel of the CD-ROM screen is under the control of the designer, who must create a unique and specific interface. Animation software, such as Macromedia Director, can be used to make control buttons and transitions, and write code to run the CD.

DVD

The DVD (Digital Versatile Disk) format supports interactivity on the computer screen, and, to a limited extent, a TV remote control. Its chief advantage is its widespread user base format and its compatibility with home television systems. With DVD authoring sofware, such as Apple's DVD Studio Pro you can put together an interactive slide presentation. Images must first be scaled and distorted to accommodate NTSC or PAL video formats (see page 164).

MAKING TYPE READABLE

Typesetting must be rasterized to become part of a computer or TV screen image. Anti-aliasing smooths the lettering, but also makes it slightly fuzzy. It's difficult to make text on a computer screen legible because it appears at about $^1/_{35}$th of the resolution of a typical printed page. To compensate, avoid sizes below 12 point, and be sure there is plenty of tonal contrast between text and background. Avoid complementary colors, such as green on red. In small sizes, sanserif fonts such as Futura and Helvetica are more readable than serif typefaces like Times and Garamond.

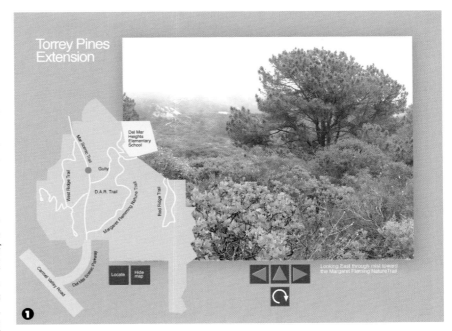

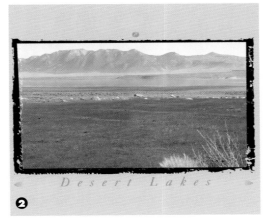

Using digital photos on CD-ROMs

1 One way to present a series of digital photographs in CD-ROM format is as a "walk-through" simulation of an environment. Simple navigation buttons cue the photographs. Other features, such as a pop-up locator map and descriptive text add information.

2 A slideshow is the simplest way to use digital images on a CD-ROM. The user can control the pace and direction of the sequence.

Digital Photos in Video

DIFFERENCES BETWEEN VIDEO AND COMPUTER DISPLAY

Computers are configured to display high-resolution images at 2,000 pixels across and more, and are readily adaptable to other screen sizes and proportions. Video systems are not so permissive. With the exception of the newly introduced HDTV and wide-screen formats, all TV monitors are fixed at the same 4:3 proportion and display the same number of pixels, no matter how large or small the monitor may be. To make matters worse, video pixels are not square like computer pixels, but are actually 90% narrower in width than a square.

VIDEO STANDARDS

There are two current systems in wide use in the world: NTSC in the United States, Canada, Japan, parts of Central and South America; and PAL in Europe, Russia, Africa, Argentina, and Brazil, Australia, the Middle East, China, and mainland Asia. NTSC uses 525 scan lines at a rate of 30 frames per second, whereas PAL uses 625 scan lines at a rate of 24 frames per second. Neither system is capable of reproducing the full color gamut of a digital photo.

ALL PIXELS ARE NOT CREATED EQUAL

Video editing programs, such as Adobe Premiere, can import digital photo stills and automatically adjust the pixel ratio from square to oblong, but this process introduces a slight degradation in image quality which will be noticeable especially if lettering is incorporated. So it's a good idea to pre-distort the image in Photoshop with a 90% reduction of the height. Still images that are used in DVD slideshows or menu backgrounds must always be created first at 720 × 540 pixels, then distorted to 720 × 480 pixels.

Video distortion

Because video pixels are oblong, not square, digital camera images imported as stills into a video editing program appear to be compressed in height and stretched out in width. The apparent distortion remains during the editing process, but the image comes out looking correct when the completed video is viewed on a TV screen. *Photo by Doris Bittar.*

Zooming in

In this title sequence, a digital photo gradually gets larger and moves down while the superimosed title fades in and out, creating the illusion of a video zoom shot.

MAKING MOVING PHOTOMONTAGES IN ADOBE AFTER EFFECTS

Combining moving graphics in layers is known as *compositing*. Compositing is a technique where film and video are combined with animations, computer graphics, lettering, and special effects.

Like Photoshop, After Effects has all the functions of adjustable layers and filters, but with the added dimension of time, making it ideal for video compositing.

It is possible to make exciting and eye-catching videos without a video camera. This example of a 30-second commercial is built entirely from digital still images. The digital flowers (in this case from the royalty-free CD "Just Flowers" from www. photodisk.com) came with an Alpha Channel which turned their backgrounds transparent when imported into After Effects. For images that do not have an Alpha Channel, silhouetting can also have been achieved by using the Chroma Key control, but the background must be a solid color.

Each flower photo was given a different speed based on how close it was to the "camera," with the closest objects moving at the fastest rates. This helped to create an illusion of depth. A blur filter, applied to the immediate foreground images, added even more to the sense of depth by making them seem out of focus. On a separate layer, a graphic of a bee weaves through the flowers, hovers, and lands on a photo of a cupcake.

How Sweet it is!

The American Classic Cupcake

COMBINING DIGITAL PHOTO STILLS WITH VIDEO

Still images from digital cameras can be combined with video footage in a video compositing program, such as Adobe After Effects. The stills are imported into an After Effects project file, along with video clips, titles, graphics, and audio files. They can be inserted at any point along a timeline and given a specific duration. Variable attributes, such as opacity, position, scale, and rotation are assigned to keyframes on the timeline, giving motion to the still images. *Matting*—a video technique that makes a designated color transparent—can be used to silhouette objects.

Combining stills and video in After Effects
1 Keyframes applied to the pizza alter its position, size, and rotation over time, making it seem to loom over the freeway exit. **2** The video footage on the top layer also has matting applied to it with the blue sky turned transparent, allowing the hurtling food to appear and disappear over the horizon.

13 Adding Another Dimension

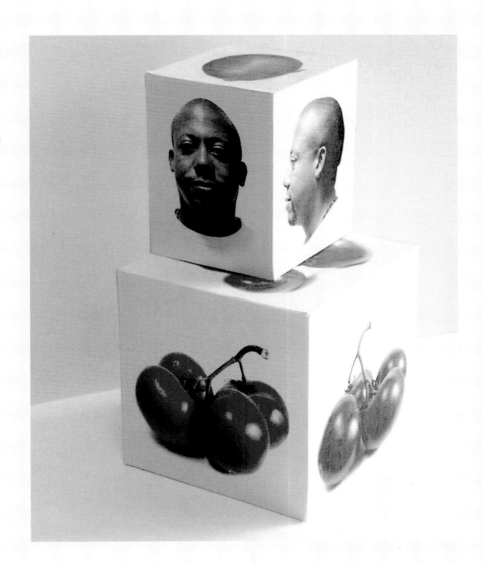

Creating Stereo Images

Unlike the real world, computer screens and pieces of paper are flat. In the 1800s, not long after the discovery of photography, the *stereoscope* was introduced as a novelty item. A stereoscope focuses each eye on a separate image from a pair of photographs taken with a special double-lens camera in such a way that the viewer perceives a single image with an illusion of depth, overcoming the limitations of a two-dimensional print.

With the advent of color printing, another way of segregating the left and right eye images was discovered: a method of printing the stereo pair of images on top of each other in complementary colored inks—usually red and green. To the naked eye, the picture looks something like a blurred black-and-white photo, but when it is viewed through special glasses with a red filter on one eye and a green filter on the other, a stereo image emerges.

In the 1950s the film industry exploited this technique with a series of 3D action movies. As with the printed images, the audience was required to wear red/green glasses and could not see the film in color. Meanwhile, an updated version of the original stereoscope, the Viewmaster, made it possible to see color stereo photographs with pairs of color slides mounted opposite each other on a plastic reel.

HOW OUR EYES PERCEIVE DEPTH

The key principle in depth perception is *parallax*, a property of perspective that makes objects that are closer to us appear to move faster than distant objects. Interestingly, it is not necessary to have two eyes to perceive depth in this way. A cyclops, for example, could perceive depth by moving his head from side to side.

Ways of viewing stereo images
1 A 19th-century stereoscope with viewing prisms and an adjustable card holder.
2 A composite stereo photo viewed with special color filtered glasses that have one red and one green eyepiece. The filters operate so that each eye sees only one color, forming a monochromatic stereo image.
3 The Viewmaster is a classic toy that displays pairs of color slides though binocular eyepieces.

Because our paired eyes see from slightly different viewpoints, parallax causes closer objects to shift horizontally more than distant ones. You can test this by holding your hand close to your face and alternately winking your eyes. The hand should appear to shift from side to side. The closer the hand, the bigger the shift.

MAKING STEREO PHOTOS

Specialized stereo cameras come with paired lenses that simultaneously expose two images—one for each eye. You could buy two identical digital cameras, lash them side by side and shoot simultaneous pictures, but you can get the same effect by shooting once, moving the camera about 4" (the distance between our eyes) and shooting again. However, this technique will not work well if there is any motion in the subject. For example, a scene with foliage on a windy day will cause "chatter" wherever parts of the scene have changed between the two shots.

VIEWING STEREO PHOTOS

You can view stereo images from digital cameras on your computer screen by opening the downloaded image files and placing them side by side by manoeuvering the windows. Standing at a distance of 3 feet from the monitor and peering at the photos with eyes slightly crossed, like the drawing on the opposite page, should produce a merged image that the brain will interpret as an image with depth. If the depth effect is reversed, with distant objects coming forward and closer ones receding, drag one of the widows to the other side, reversing their order. If you have an old-fashioned stereoscope, you can make your own stereo cards by mounting paired printouts—in glorious color.

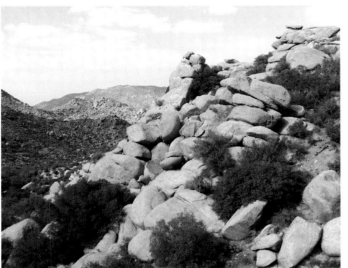

Right eye image

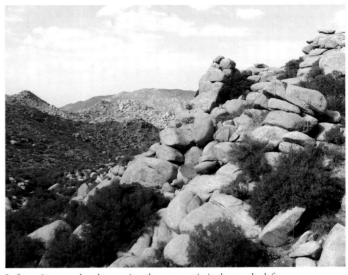

Left eye image, taken by moving the camera six inches to the left

MAKE YOUR OWN STEREOSCOPE

If the eye-crossing technique for viewing stereo photos, described at left, doesn't work, try making your own stereo viewer.

This viewer works on the principle of segregating the images that reach the left and right eyes. All you need is a page layout program, a printer and one sheet of paper.

Arrange the stereo pair of digital photos as shown, rotating the left eye image 90° clockwise, and the right eye image 90° counter-clockwise; print, fold and cut. Place your nose in the fold of the paper and try to merge the two images. It might help to bend the paper back and forth to focus them.

Looking at the stereo images

To view stereo photographic pairs without equipment, the left eye must focus on the right image and vice versa. Begin by focusing on the tip of the nose. The two photos beyond should become three, and will be out of focus. Now slowly refocus on the middle picture until a stereo image forms sharp and clear.

Quite apart from looking ridiculously cross-eyed, some people have difficulty making their eyes work in this manner. If you are unable to make this work, try a different method as described in "Make Your Own Stereoscope" at right.

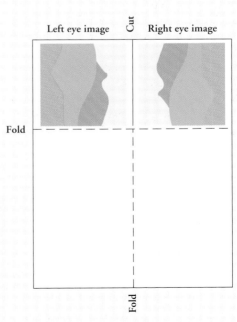

Left eye image Cut Right eye image

Fold

Fold

Creating 3D Images with Texture Maps

USING 3D SOFTWARE

The advent of powerful personal computers has engendered many programs that derive 3D images from virtual objects created by the user. With lighting and atmospheric effects, shadows and reflections, these programs can produce stunningly realistic environments.

A typical 3D model consists of a number of shapes arranged in a virtual three dimensional space. The shapes can range from simple geometric "primitives"—cubes, spheres, cones and so forth—to complex, free-form objects like mountains or human figures. The process of generating the shapes themselves is called *modeling;* the production of a final image from a particular viewpoint is called *rendering*. 3D programs provide virtual "cameras" that can be placed anywhere within the model, and can be pointed in any direction.

3D shapes can be given various surface attributes that define the color, opacity, shininess and smoothness of an object. A semi-gloss, opaque white sphere with a dimpled surface, for example, becomes a golf ball when rendered. In addition to these attributes, any kind of pixel-based image can be applied to 3D model surfaces. These may include scanned images or images from digital cameras. Images that are projected onto the surface of 3D objects are known as *texture maps.*

MAKING A TEXTURE MAP

Most 3D programs require that a texture map be in PICT format at 72 pixels per inch. If you want the image to repeat several times across a surface, like wallpaper, you need to modify the image to form a seamless tile (see page 121).

APPLYING TEXTURE MAPS TO 3D MODELS

It may take considerable experimentation to find the right scale, coverage and orientation of a texture map. To make matters more complicated, different mapping parameters produce dramatically different results. Some of the various methods of mapping a texture onto a shape are shown below.

SOME 3D PROJECTION MAPPING METHODS

Cubic	Cylindrical	Spherical	Planar	Wrapped	Decal

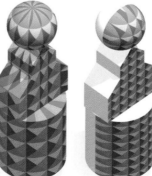

A combination of digital photos of soil textures have been mapped onto an elongated cube in this 3D diagram of a solar-powered well.

Using a photo as a 3D texture

In this scene from the animated short film *The Adventures of Nora Bell*, a digital photograph of a brick wall has been mapped onto a 3D object. The rendering faithfully applies the laws of perspective to the rows of bricks and enhances realism by adding shadows.

The poster on the wall is also a texture map, scanned from a public domain source.

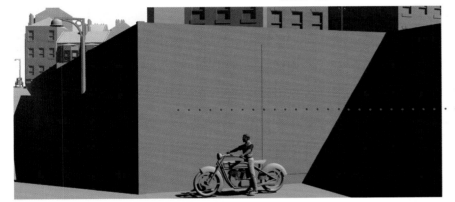

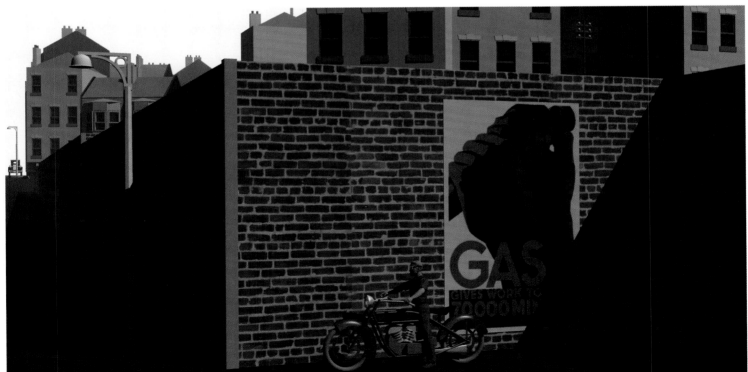

Creating Solid Objects with Digital Photos

PRODUCING PACKAGE DESIGNS

Because most packaging material ends up as land-fill, package printing is generally not as refined as printing in books, brochures, catalogs and magazines. Package printing's lower quality requirements make it quite suitable for using digital photography as an element in the graphic design. This is especially true of cartons and labels that are printed on utility-grade paper and tag-board. Nevertheless, one should be wary of enlarging a 1–2 megapixel image too much beyond the 8" × 10" size limit.

Food and beverage packaging is printed in as many as six colors, but these are not usually the process primary colors of cyan, magenta, yellow and black (CMYK), and they may include silver and gold. As with the example shown on this page, it may be necessary to break down a digital photograph into several non-primary colors.

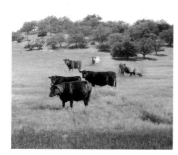

Simplifying the colors
1 A five-level posterization made the image suitable for carton printing. The addition of black type brought the total of ink colors to six. **2** The colors in the typesetting are taken from the palette of the posterized image.

PRODUCING SCULPTURES

In contrast to a package design, where a container is decorated to induce a person to buy what's inside it, a sculpture stands alone. It *is* the product. A sculpture based on digital photography may have commercial value, or it may merely be an expression of exuberance. In any case, making prints, mounting them, cutting and folding in various ways can add another dimension to a two-dimensional medium

Use heavy paper that will withstand scoring and folding, or spray-mount prints onto tag-board or foam core. A sharp art knife with replaceable blades is an essential tool. Use only water-soluble glues on foam core; other glues will melt the foam.

Flying photography
A digital photo of clouds makes a dandy paper dart. Use lightweight inkjet paper and allow time for the ink to dry; otherwise the paper will be too floppy.

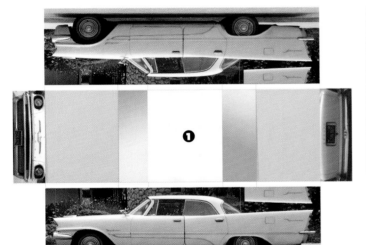

Making a reality-based toy
Three photos of a 1950s DeSoto—a side view, a front view, and a back view—form the basis of this model. The construction principle is based on the cheap tin-plate toys from the early 20th century. The model was cut from a single inkjet print on heavy glossy paper. The graphic for the top of the car **1** was created from sampling the colors from the side of the car and filling rectangles.

To make the model, I cut out both of the side views and glued them to the top after folding it and bending down gluing tabs **2**. (Note the extra parts for the inside tailfins.)

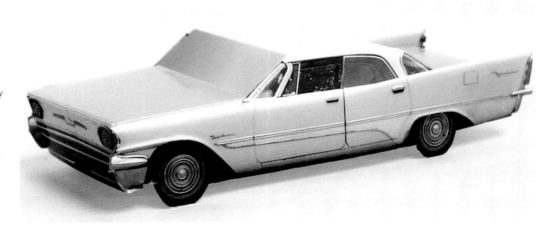

CREATING PAPER CUTOUTS

Once a photograph is printed, it becomes a flat object on paper. But paper can be folded and cut out into many different shapes. It is this particular dimensional attribute of paper that makes it possible to bend and snip digital photos to make pop-up book pages, cut out objects layered like stage sets, and even make photographic flying objects. The playful quality of paper combined with the realism and immediacy of digital photography is likely to lead the experimentally inclined into new forms of visual media.

Making a pop-up photo
This pop-up style horse and buggy was made by bending and cutting two prints of the same photograph.

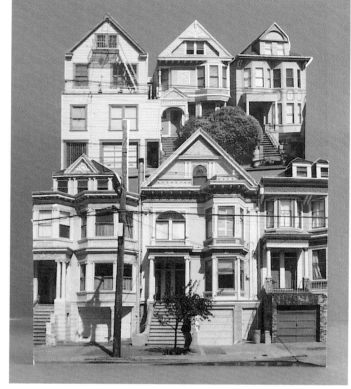

Making a model home
I cleaned up the original photo **1** by removing a parked vehicle with the Photoshop/Elements Clone Stamp tool **2**. I created another layer for the gable trim **3**, then inkjet printed the two images on heavy paper. With an art knife and glue, I made a paper facade with a slit cut in the matt-board roof for the chimney **4**.

Making a cutout street
These prints of San Francisco Victorians have been mounted on foam-core board. The roof-lines were trimmed with an art knife.

Index

START WITH
A DIGITAL
CAMERA

START WITH
A DIGITAL
CAMERA

JOHN ODAM is an award-winning graphic designer and the principal of Beardsley and Company, Inc. John grew up in England, and has worked in publishing since 1967 as a designer and art director.

He was for many years art director of the early desktop-published *Verbum* magazine and has contributed articles to *Step-By-Step Electronic Design* and *Before & After.* He is a co-author of *The Gray Book, Start with a Scan,* and *Getting Started with 3D.* He has contributed many articles and illustrations to magazines and books throughout the world.

In addition to graphic design, John has branched out into other media. He recently won the Adobe Digi Award for his animated feature *The Adventures of Nora Bell,* and is currently involved in making video documentaries on social and historical issues in California.